IMAGES
of America

CARMEL
BY-THE-SEA

Monica Hudson

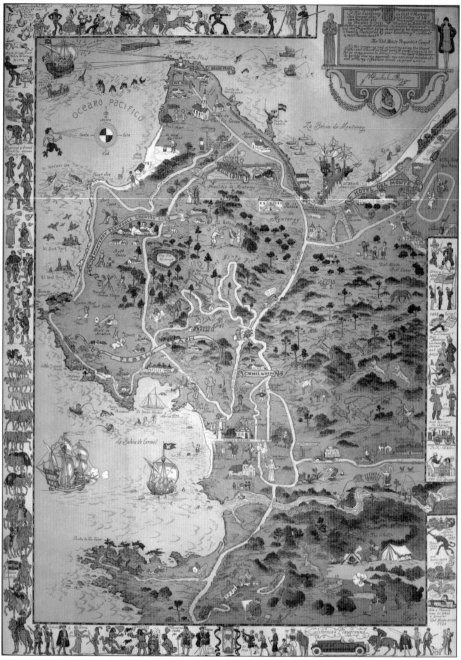

This humorous map was drawn by artist Jo Mora. It shows the relationship of the village of Carmel-by-the-Sea (low center) to the rest of the Monterey Peninsula. Mora was a painter, sculptor, illustrator, and muralist, as well as an artist-historian and writer. He made the Peninsula his home for almost four decades. (Lacy Williams Buck collection.)

ON THE COVER: A group of artists gathered to paint on Carmel Beach, *c.* 1906. (Erin Gafill collection.)

IMAGES
of America

CARMEL
BY-THE-SEA

Monica Hudson

ARCADIA

Published by Arcadia Publishing
Charleston SC, Chicago IL, Portsmouth NH, San Francisco CA

Printed in the United States of America

Library of Congress Catalog Card Number: 2005939051

For all general information contact Arcadia Publishing at:
Telephone 843-853-2070
Fax 843-853-0044
E-mail sales@arcadiapublishing.com
For customer service and orders:
Toll-Free 1-888-313-2665

Visit us on the Internet at www.arcadiapublishing.com

Maya, this is for you; I know you can see it from where you are.

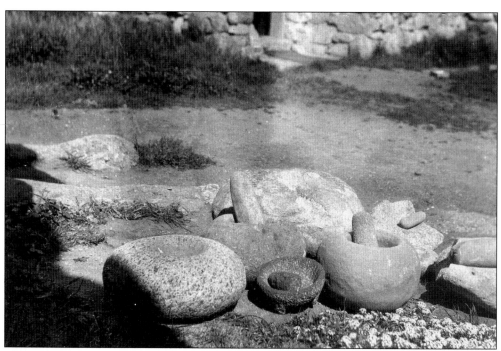

This photograph is in memory of the Rumsien people, who called this beautiful land home for centuries before white men came. The stone mortars and pestles were used by them to grind acorns, which was a part of their diet. Many Native American artifacts were found on Carmel Point at the beginning of the 20th century. These were photographed in the garden of poet Robinson Jeffers's Tor House. (Tor House Foundation Collection.)

CONTENTS

ACKNOWLEDGMENTS

I want to thank the many people who helped me prepare this book. Their genuine interest and encouragement, over the many months it took to assemble this collection, has made this project possible. My search for new and unusual photographs has led me to many descendants of early Carmel settlers, all of whom gave generously of their time and shared their photograph collections and their treasured memories. We met in person, by telephone, and via e-mail, and I feel richer for knowing all of them: Amalia Gilette, Amy Ledbetter, Ann Luker Klein, Barney Scollan, Charis Buckminster, Cathrine Wenner, Clayton Neil, Clyde and Pam Klaumann, Cynthia Chaplin, Colin Kuster, Debbie Sharp, Dennis and Ray Narvaez, Denny Richards, Don Freeman, Donna Manning, Eldon Dedini, Eleanor Laiolo, Erin Gafill, Francesca Farr, Glen and Marion Leidig, Gordon Miamoto, Howard Brunn, Jane Galante, Jean Hagemeyer, Jean Rodriguez, Jennefer Lloyd Wineman, John Kerby-Miller, John Schiffeler, Julie Ricketts, Kay Prine, Alene Fremier, Lillian Hazdovac, Lisa van der Sluis, Mariam Melendez, Marsha Ryder, Michelle Raggett, Muriel Pyburn, Nancy Morrow, Nicki McMahon, Owen Greenan, Pat Sippel, Roxy Blanks, Sally Young, Sheila and Wynne Hutchings, Shirley Humann, Sue McCloud, Tom Gladney, Vincent Torras, Virginia Evans, and Warren and Rick Masten.

At the very beginning, photographer Alan McEwen made materials from his and his father's extensive archives available and gave me the first personal insight into the amazing community in which he had grown up. Lacy Williams Buck and Susan Draper loaned me photographs and valuable research materials and connected me to many people in the community. Linda Lachmund Smith scanned many of her grandmother's pictures for me, and photographer John Livingstone lent his photograph. Steve Crouch and Harold Short gave generous permission to use their fathers' work. Harold also used his expertise to carefully repair or improve all the scanned photographs, and William Minor shared his great knowledge of the local jazz history.

Research materials and images came from a number of public and private collections. First and foremost, I received amazing support from Denise Sallee, librarian for the Henry Meade Williams Local History Department at the Harrison Memorial Library in Carmel, California, which is the source of many of the photographs included here. I want to thank the members of the Carmel Heritage Society, Joan Hendrickson from the Tor House Foundation, Leslie Fenton from the Carmel Fire Department, Kelly Lepai from the Carmel Youth Center, Meryl Dun from Carmel's All Saints Episcopal Church, and Paul Miller from the Carmel Pine Cone. I am grateful for the assistance of archivists Dennis Copeland of the Monterey Public Library, Jim Conway from the City of Monterey's Colton Hall Museum, Larry Scrivani from the Diocese of Monterey, Esther Trosow from the Pacific Grove Museum of Natural History, and Mona Gudgel of the Monterey County Historical Society. California Historic Views, the large collection of Pat Hathaway, was the source of some amazing treasures.

I want to thank Hannah Clayborn, editor at Arcadia Publishing, for her patience and understanding when this undertaking took much longer than expected. I am grateful to fellow Arcadia authors Kent Seavey and Jeff Norman for answering last-minute questions. And finally, my heartfelt thanks to my husband, John Hudson, and friends Marguerite Moore, Roland Garcia, and Harold Short for proofreading the manuscript and providing artistic and editorial advice as well as tea and cookies many a late night.

INTRODUCTION

Along the crescent-shaped shore of Carmel Bay on the southwestern slope of the Monterey Peninsula lies the charming village of Carmel-by-the-Sea. The name Carmelo first appeared on a map in 1602, when the expedition led by explorer Sebastian Viscaino entered Monterey Bay. He took possession of the area for his king, Philip III of Spain. While climbing a hill south of the bay, three Carmelite friars who accompanied Viscaino were reminded of the biblical Mount Carmel and asked to name it Mount Carmel, in honor of their religious order. They would call the river that flowed through the beautiful valley before them El Rio Carmelo. Thus, Carmelo existed as a name on that map before Jamestown was founded, and well before the Pilgrims landed at Plymouth Rock.

The first attempt to establish a community here was made by Fr. Junipero Serra, the Franciscan missionary and founder of the mission chain that eventually spanned the length of California. In 1771, after just one year in Monterey, Mission San Carlos Borromeo was moved to the northern bank of the Carmel River, near the lagoon where the river enters the Pacific Ocean. Thus, la Misión San Carlos Borromeo del Rio Carmelo was founded.

The native Rumsien people who occupied the Monterey Peninsula, the lower Carmel Valley, and the northern end of the Big Sur coast became the chosen population, serving as unpaid labor for the Carmel Mission. The Spanish empire in the New World planned to convert the native populations to Christianity and create agrarian villages around the missions. In California, however, the process of changing the native hunter-gatherer way of life to a European peasant model failed to take hold before Mexican independence caused the missions to be secularized. In the mid-1830s, the Carmel Mission was abandoned and began to fall into ruin.

It was not long before the first of several developers had visions of a future resort village. Following the model of Pacific Grove Retreat, founded by Methodist church leaders, Santiago J. Duckworth, a young Monterey businessman, decided to form a Roman Catholic community utilizing the Carmel Mission, which was already drawing tourists, in early 1888. Much of the land needed for his enterprise was in Rancho Las Manzanitas, owned by French businessman Honore Escolle, with whom Duckworth stuck a bargain. On May 1, 1888, Duckworth filed a subdivision with the county recorder, and Carmel City, a Catholic summer resort, was born.

Between 1886 and 1891, Abbie Jane Hunter of San Francisco became involved in Duckworth's project. By 1892, the San Francisco-based Woman's Real Estate Investment Company handled the subdivision and advertised it under a new name, "Carmel-by-the-Sea," as an ideal summer resort. The recession years of 1893–1897 ended Hunter's plans, and it was not until 1902, when Frank Powers and Frank Devendorf formed the Carmel Development Company, that the dream of a lasting community was realized.

Having independently acquired Carmel property, these men formed an ideal partnership. Powers provided the capital and took care of all the legal work, while Devendorf was an on-site general manager. Both men brought a love of the outdoors, an appreciation for nature, and great respect for the serene beauty of the land they were developing.

From the beginning, they strove to create a community that harmonized with the environment, a new idea in the West. Devendorf's first brochure was sent out in the spring of 1903 "to the School Teachers of California and other Brain Workers at Indoor Employment." He offered bargain prices

at the Pine Inn to attract buyers and sold lots at advantageous terms. Word got out, and the next summer, people from California's hot interior came to camp, often buying lots. By 1905, David Starr Jordan, president of Stanford University, had built a house on Camino Real. Other faculty members soon followed and built small summer cottages.

The devastation of the 1906 San Francisco earthquake and fire was a boon for development, as the magnificent scenery, mild climate, and peaceful setting inspired many refugees to become permanent residents. An intellectually tolerant community evolved, where scientists, writers, liberal thinkers, musicians, playwrights, actors, painters, and photographers lived, worked, and played side by side with professionals, handymen, shopkeepers, craftsmen, and deliverymen—each one interdependent on the other.

Inevitably, growth brought change, and early on, pitched battles were fought to keep "progress" from endangering the residential character and Carmel's chosen way of life. A "Magna Carta" was drawn up to help protect those values. As a result, many of the quaint, whimsical cottages, quietly tucked under the tall canopy of Monterey pine and California live oak, still exist. The narrow streets through this urban forest give way at the center to a small, carefully defined business district devoid of neon signs, fast food places, and barren parking lots.

However, gone are the many resident service businesses—plumbers, electricians, and hardware stores—replaced by galleries, gift shops, and restaurants that draw tourists from around the world. The current property values would astound the founding fathers and have inevitably had an impact on the life and demographics of this village. But the unique character, flavor, and mystique of this little paradise, set in incomparable natural beauty, still exists, a treasure to behold, enjoy, nurture, and preserve.

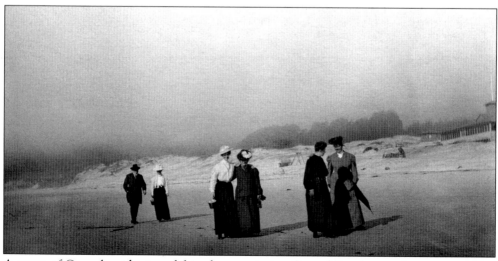

A group of Carmel residents and friends are enjoying Carmel Beach on a foggy summer day in 1915.

One

AN ELUSIVE VILLAGE

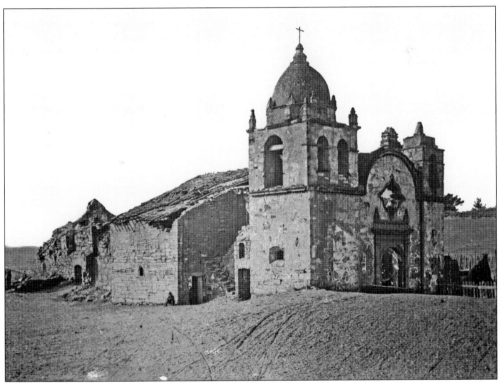

The first attempt to create a community at this location was made in 1771, when Fr. Junipero Serra founded La Misión San Carlos Borromeo del Rio Carmelo. The Spanish-born Franciscan priest came to California as Father Presidente, the founder of the mission system that would eventually number 21 missions, extending from San Diego to Sonoma, north of San Francisco. San Carlos Borromeo, his second mission, became the seat of his administration. This 1880 photograph, one of the earliest existing views, was taken almost 100 years after Serra was laid to rest here in 1784. The church is in sad disrepair, and the outbuildings are in total ruins. The man sitting down is most likely Christiano Machado, who lived with his family on the mission grounds and was the longtime caretaker. (Photograph by C. W. J. Johnson; courtesy of Pat Hathaway Collection.)

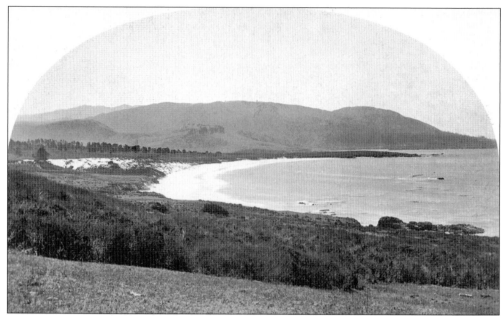

This 1880 view of Carmel Bay, Carmel Point, and the Santa Lucia Mountains is probably what the three Carmelite friars who came with Sebastian Viscaino's expedition beheld when they came over Carmel Hill in 1602, five years before Jamestown and 18 years before the Pilgrims landed at Plymouth Rock. The river named in honor of their monastic order, El Rio Carmelo, thus bestowed the name Carmelo on this land for the first time. (Photograph by C. E. Watkins; courtesy of Pat Hathaway Collection.)

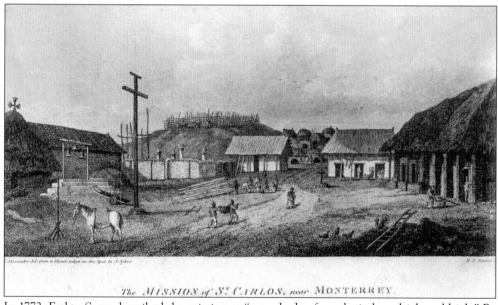

The MISSION of S.CARLOS, near MONTERREY.

In 1772, Father Serra described the mission as "a stockade of rough timber, thick and high." By 1793, when J. Sykes, who came with George Vancouver's expedition, made this sketch, visible are the sacristy at left, two houses, huts for married natives, a corral for livestock, chimneys of kilns protruding behind a wall, and a temporary church to the left of the cross, which Serra had erected the day he arrived. (Harrison Memorial Library Collection.)

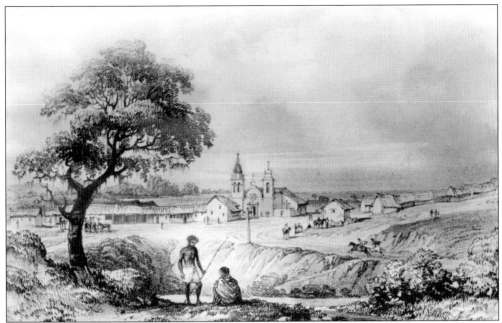

The cornerstone for the present-day Carmel Mission church was laid in 1793 by Father Serra's successor, Padre Fermin Francisco de Lasuen. Four years later, in September 1797, the finished stone church was dedicated with religious ceremonies and a fiesta. This 1823 drawing depicts the mission quadrangle built of adobe (center) and the little Native American village to the right. (Harrison Memorial Library Collection.)

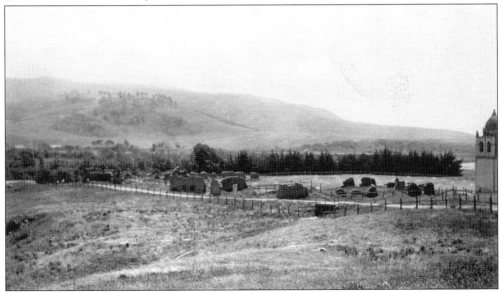

When secularization by the Mexican government was finally implemented in 1834, the native Rumsien people of this area, who were Christianized, were in no position to lay claim and hold on to the land that had been held in trust for them by the padres through the king of Spain. The mission and the village around it were abandoned. This photograph, taken around 1880, shows how all but the church has already melted back into the soil from which it was made. (Harrison Memorial Library Collection.)

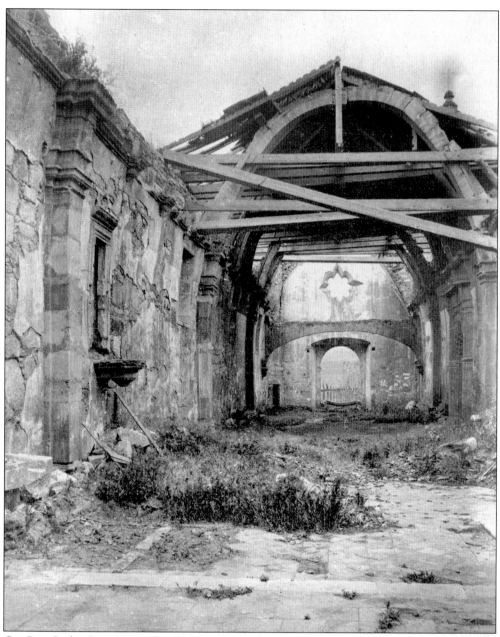

On San Carlos Day, November 4, 1879, Scottish writer Robert Louis Stevenson visited the Carmel Mission to hear the only mass of the year. He was saddened by the decay, and reflected on how such buildings would be preserved in Europe, partly to attract tourism. He observed that "so piously, in these old countries, do people cherish what unites them to the past. Here, in America, on this beautiful Pacific Coast, you cannot afford to lose what you have." He continued by confessing how it struck him that a "fine old church, a fine old race, both brutally neglected; a survival, a memory and a ruin." This c. 1880 photograph tells an eloquent story. The collapsed roof had left debris inside, four feet deep in places. The cattle grazing the surrounding area had free access. Pigeons, owls, and literally thousands of ground squirrels made it their home. (City of Monterey, Colton Hall Museum Collection.)

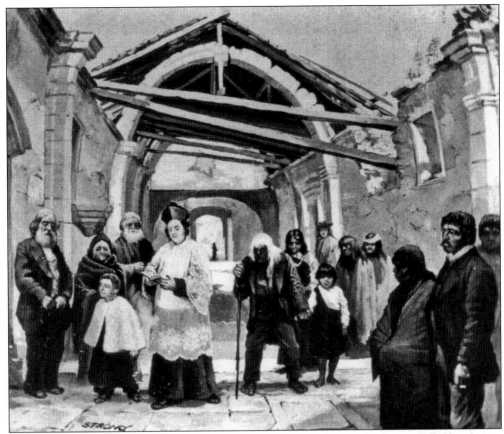

This sketch by Joseph Strong, who accompanied Stevenson, shows Jules Simenau (left), mission-born Maria Loreta Onesimo and her husband, James Meadows, an unidentified altar boy, and Fr. Angel Delfino Casanova. The man with the cane is "Old Ventura," the blind Native American who led the Gregorian chants, according to Stevenson, "like a voice out of the past. They sang by tradition, from the teaching of early missionaries long since turned to clay . . . which preached a sermon more eloquent than his own [the padre's]." (Monterey Public Library Collection.)

Stevenson's article sparked interest, and by 1883, Father Casanova had succeeded in having a steep roof put on the church. People came by the hundreds to attend the consecration ceremonies on August 28, 1884. The mission, pictured here in 1915, became a regular tourist stop, especially for the guests of the Hotel Del Monte on their trips around the 17-Mile Drive. (Photograph by William Ireland; courtesy Charlotte Boyd Hallam collection.)

In 1888, there was hope that train service would be extended from Monterey to the mouth of the Carmel River. Santiago J. Duckworth saw this as an opportunity to develop a community similar to the Pacific Grove Retreat. He had his eye on the Rancho las Manzanitas on the south side of Carmel Hill. It belonged to Honore Escolle, pictured here in the 1860s. (Muriel Pyburn collection.)

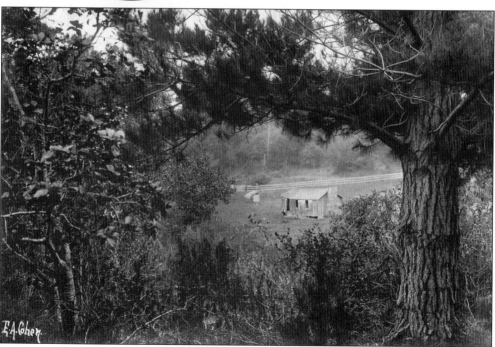

Escolle, a hardworking businessman, had come from France to Monterey in 1853. He bought the land for pasturage and firewood, which he needed for his Monterey enterprises: a bakery, pottery kiln, and brickworks, where he also used the fine white Carmel sand. This photograph of the Escolle Cabin at Las Manzanitas was taken by E. A. Cohen, *c.* 1900. (Erin Gafill collection.)

Santiago and his brother Belisario Duckworth entered into a contract with Escolle. They filed a plat of Carmel City at the county recorder's office and advertised the Catholic Summer Resort adjoining the Carmel Mission. By the end of 1889, they had sold almost 200 lots, many of them to schoolteachers from the San Francisco area. (Harrison Memorial Library Collection.)

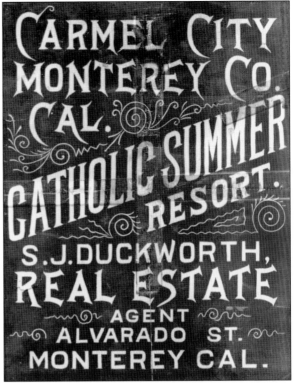

One of the early buyers was Abbie Jane Hunter, a San Francisco businesswoman who soon became an associate of the Duckworth brothers. She moved here with her son Wesley Hunter and her brother Delos Goldsmith, a carpenter. He built most of Carmel's early improvements, including the bathhouse above the beach at the foot of Ocean Avenue, pictured here in 1904. (Jane Galante collection.)

Hunter and her Women's Real Estate Investment Company were handling the subdivision by 1892, and the name Carmel-by-the-Sea was used for the first time. Goldsmith built one of the earliest houses on the corner of Fourth and Guadalupe Street, occupied today by the Carl Cherry Foundation. Note the mature Monterey pine forest in this part of town. (Harrison Memorial Library Collection.)

The depression years of the 1890s drove the Women's Real Estate Investment Company out of business, and by 1901, Frank Powers, a San Francisco lawyer, had acquired Carmel property. According to descendants, he was paid in land near the Carmel Mission in lieu of a legal fee. Frank, a nature lover, thought that Carmel was the most beautiful place in the world. He is pictured here around 1910 in front of "The Dunes," his Carmel home. (Erin Gafill collection.)

Soon Frank Powers and his wife, Jane, would hold title to over 1,600 Carmel lots. For visits, they chose a rustic old ranch house near the beach and called it "The Dunes." It had been built by Irish pioneer John Monroe Murphy by 1872, and possibly even as early as 1846. In this 1905 photograph, the family poses next to the home. From left to right are Polly, Frank, Madelaine, Jane Gallatin Powers, and Dorcas. (Erin Gafill collection.)

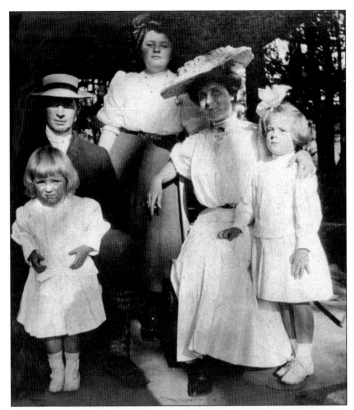

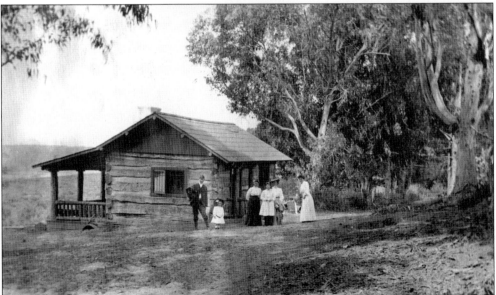

Jane was a European-trained artist. She and Frank preserved the adjacent old barn, built of rough-hewn pine logs, and adapted it as her studio. Here the building is tucked under tall Eucalyptus trees, with Frank Powers, Polly, two unidentified women with Madeline, and Jane (at right). This photograph was taken shortly after the barn's 1905 transformation into the first Carmel artist studio, which still exists today near the Pebble Beach gate. (Erin Gafill collection.)

Powers also purchased the available Escolle holdings, among them an 80-acre parcel. Pictured around 1900 is the entrance gate to this oak- and pine-studded parcel, where poet George Sterling would soon buy a lot. Powers, who had a busy San Francisco law practice and an active social life revolving around the Bohemian Club, soon realized that he needed a manager or partner. (Photograph by E. A. Cohen; courtesy Erin Gafill collection.)

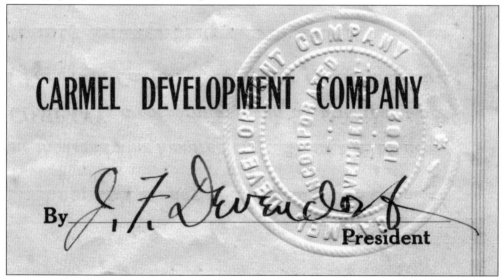

James Frank Devendorf was involved in real estate in San Jose. When Santiago Duckworth approached him, they made a land trade. Devendorf also realized he needed a partner, and he found that Powers not only owned large portions of Carmel but could provide the financial backing to see such a venture through. Together they formed the Carmel Development Company in 1902, and its seal and signature of Pres. J. F. Devendorf authenticated all purchases. (Reamer-Elber family collection.)

A flag-draped Frank Devendorf stands in front of his cottage on Lincoln and Sixth Streets on July 4, 1905. Devendorf first saw Carmel Bay in 1890, while vacationing with his family at the Pacific Grove Retreat. The vision of breaking surf, against an arc of white beach and dunes backed by tall pines, never left him. Devendorf's kindness, generous spirit, and enthusiasm, combined with practicality and competence, made him perfect to attend to the daily needs of the growing village. (Jane Galante collection.)

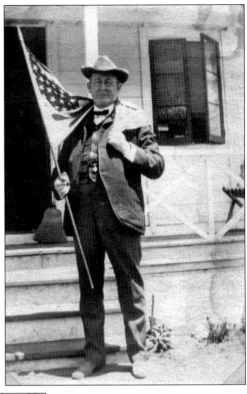

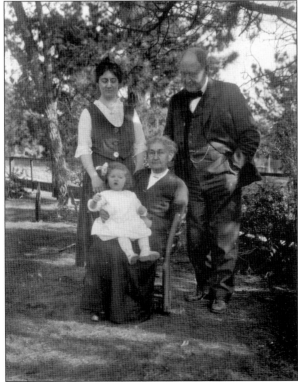

Papa Devendorf, or "Devy," as he was affectionately called, spent weekdays working in Carmel as general manager. On weekends, he commuted home to his family in Oakland. During some vacations and holidays, his wife, Lillian, and four daughters joined him at their prefabricated home in the center of town. In this family photograph, taken in their Carmel garden around 1909, Devy and Lillian are enjoying the company of their first grandchild, Elizabeth, with their daughter Myrtle looking on. (Jane Galante collection.)

19

Frank Powers's family began to live in Carmel on a more permanent basis after Jane acquired her artist's studio. Frank came down from San Francisco on weekends. Here we see him, his children Dorcas and Gallatin, and a friend, making their way up steep sand dunes near their house in 1909. Tons of fine, white sand had been hauled away by the previous owner, Ann Murphy, some shipped as far as Hawaii. (Erin Gafill collection.)

The Carmel Development Company had taken over some improvements made by the previous developers, such as the Hotel Carmelo (left) on the corner of Ocean Avenue and Broadway, today's Junipero Street. An attractive, two-story building, it was opened in 1889 by a Mrs. Hunter. The town had been laid out on a grid pattern, without regard to the topography of the land, so Devendorf tried to stem the resulting erosion by planting as many trees as possible, restoring and creating the forest that exists today. This photograph, taken before 1903, shows the right-of-way for Ocean Avenue, cleared of trees. (Pat Hathaway Collection.)

Two

"School Teachers and Brain Workers"

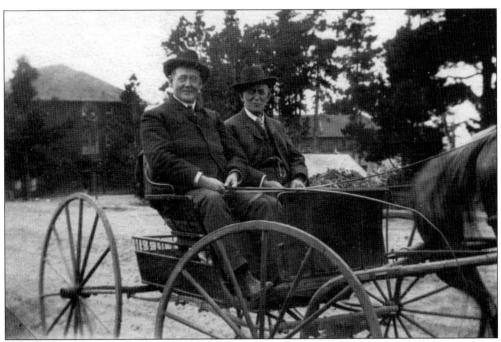

Powers and Devendorf shared a common vision of creating a community that would respect and enhance the natural beauty of its setting. However, they needed to attract residents. After just six months of hard preparation, in the spring of 1903, they sent their first brochure out, appealing "to the School Teachers of California and other Brain Workers at Indoor Employment." It promoted a "Seaside town on Carmel Beach in Pine Forest alongside Carmel Mission" and advertised "a first-class easy graded road from the railroad station in Monterey." Rooms were prepared at the Pine Inn, and for overflow guests, tent accommodations were available. One tent is visible to the right of the buggy in this 1905 photograph. Devendorf, pictured here with Giles Congdon in the buggy, was always ready and happy to take a prospective buyer around town to find just the right lot. (Jane Galante collection.)

The long-awaited extension of the railroad from Monterey was still only a hope. In the meantime, the Carmel Stage, pictured here *c.* 1905, picked up visitors at the Southern Pacific depot in Monterey. The three-mile trip over the hill would take about two hours, weather and road conditions permitting. At the steepest part of the grade, the men were often asked to get out and walk to ease the burden on the horses. (Harrison Memorial Library collection.)

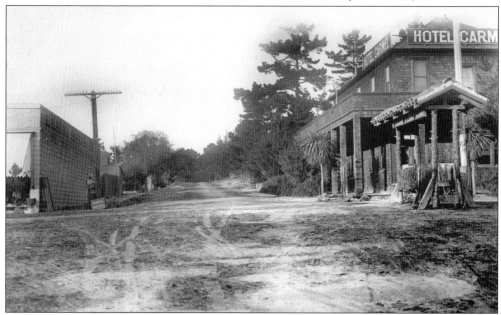

To water the horses, a trough was installed at the top of the hill near the present-day statue of Fr. Junipero Serra. Another trough is pictured here in 1915. This photograph looks up San Carlos Street where it crosses Ocean Avenue. The water trough is in the middle of Ocean, in front of the Hotel Carmel. Leidig's grocery store is at left, with the power pole on the sidewalk. Electricity had arrived just the year before. (Monterey Public Library Collection.)

To provide accommodations for prospective customers, the Carmel Development Company moved the Hotel Carmelo on rollers four blocks closer to the bay—a daunting task, as Ocean Avenue was pitted with treacherous holes—and renamed it the Pine Inn. Bargain prices aimed to attract guests who would hopefully buy property. In 1904, L. S. Slevin took this photograph of the Pine Inn, the two-story Hotel Carmelo building now part of it, with tent accommodations to the right. (Harrison Memorial Library Collection.)

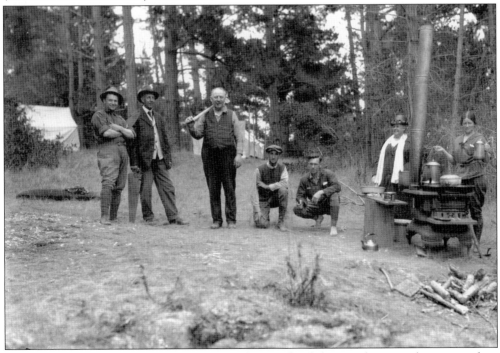

Devy made arrangements to have a tent set up for some hardy buyers who wanted to occupy their new lot right away, even before their cottages were built. He had established a general store for the convenience of villagers and ordered cook stoves, so the new residents soon had the comforts of home. This photograph, taken by Lewis Josselyn, shows a family camping and cooking on Ocean Avenue and Guadalupe Street in August 1921. (Pat Hathaway Collection.)

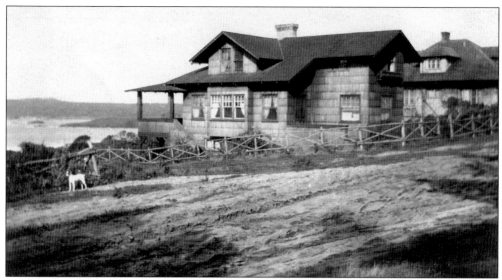

First-year lot sales were disappointing for the Carmel Development Company, even though Devendorf lowered prices, offering monthly payments of just $5. In 1905, David Starr Jordan, the first president of Stanford University, who had written an enthusiastic description of Carmel Bay during his Pacific Coast fish survey in 1880, built a house on Camino Real and Seventh Street. Others followed, including Stanford botany professor George Pierce, who soon built this home, pictured around 1910, on the same street. (Harrison Memorial Library Collection.)

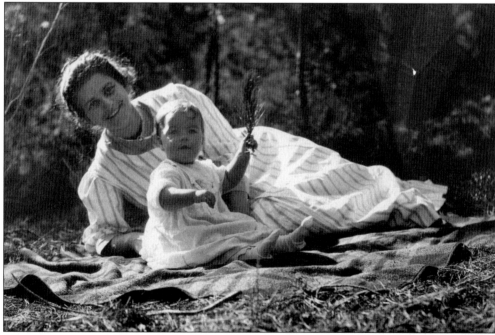

About the same time, brilliant entomologist Vernon Kellogg, Jordan's assistant, moved his young family to Camino Real, soon to become known as "Professors Row." Charlotte Kellogg is pictured here with her baby daughter Jean, whose toy is a readily available pine bough. Both Charlotte and Jean thrived in the creative atmosphere of their new home. Charlotte was a talented actress and writer, and Jean would become a well-known painter. (Harrison Memorial Library Collection.)

Word spread in the academic community about the exquisite, creative village. Many scientists camped here in summer, like this family that was photographed in 1915 by Lewis Josselyn. One such visitor, Dr. Daniel MacDougal, established the Carnegie Institute's Desert Botanical Laboratory in Tucson, Arizona, in 1903. Interested in establishing a second facility here, he made arrangements for a little building and some land at Junipero and Twelfth Avenue in 1909. The Coastal Laboratory operated until the early 1940s. (Pat Hathaway Collection.)

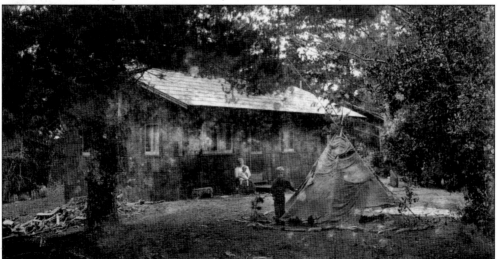

Prof. Francis E. Lloyd, who divided his time between the two laboratories, brought his family to Carmel for the first time in 1911. They loved it so much that the Lloyds built this home on San Carlos Street and Twelfth Avenue. The professor spent the academic year teaching at McGill University in Canada, while his family remained active here. This 1912 photograph by S. L. Slevin shows Mrs. F. E. Lloyd with her sons David and Frank. (Lloyd family collection.)

The sand stretched from the beach up to Monte Verde Street. The lower slopes were covered with manzanita, coyote bush, and dotted with a few mature Monterey pines, like this one on Casanova Street, photographed in 1908. Devendorf carefully planned the streets around the trees, which helped stem erosion. In addition, he planted new trees and gave new homeowners seedlings to forest their lot. Since Carmel's incorporation in 1916, all trees are protected. (Harrison Memorial Library Collection.)

Poet Robinson Jeffers (on horseback) and his wife, Una, lived in this log cabin at Monte Verde and Fourth Avenues during the year 1914. They had heard about the colony of writers, but were not prepared for what they felt when their stagecoach topped Carmel Hill. He later said, "we looked down through pines and sea fog on Carmel Bay, it was evident that we had come without knowing it to our inevitable place." (Tor House Foundation Collection.)

Mabel Gray Lachmund is pictured in 1914 with her husband, Stanford professor Stewart Young, in front of her cottage on Lincoln Street and Fourth Avenue, which is still standing today. Mabel and her two boys first camped in 1903 while she looked for land. An accomplished concert pianist, she gave the first music lessons in Carmel. Her 700-square-foot cottage, one of the first to be built by M. J. Murphy in 1905, became a bohemian gathering place. (Linda Lachmund Smith collection.)

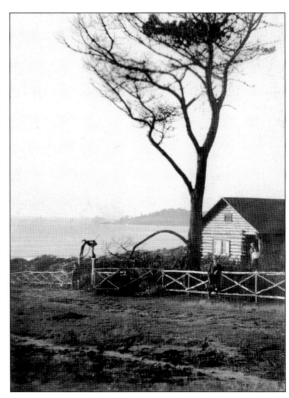

Homes in Carmel were usually identified by their names, a tradition that continues today, as houses in the city limits do not have street numbers. In the early days, it was easy to find "Log Haven," as it stood solitary on Eighth Avenue near the beach. Harry Johnson is leaning against the fence, and his wife and his sister, artist Ida Johnson, are on the porch in this c. 1918 photograph. (Harrison Memorial Library Collection.)

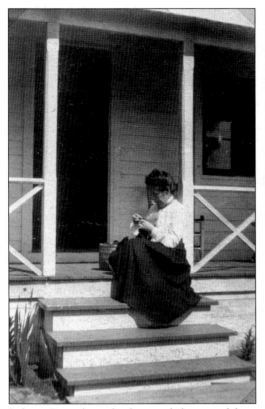
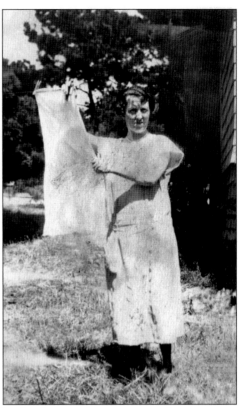

Life in Carmel revolved around the out-of-doors for shopkeepers, housewives, and scientists as much as artists. They were drawn by the pure, white silica sand, the pine forest, and the promise of a resting place for the nerve-weary, as advertised in the company brochure. At left, sitting on the steps of her cottage, Mrs. Devendorf is sewing. An unidentified neighbor, at right, hangs out the wash to dry, c. 1910. (Jane Galante and Pat Sippel collections.)

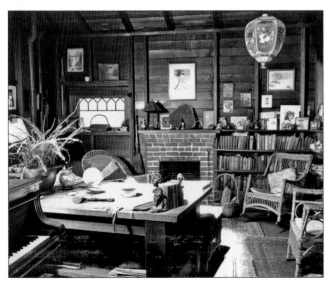

This 1949 photograph by portrait artist Murle Ogden shows the small interior of Mabel Gray Lachmund's cottage. Daisy Bostick describes the early cottages best in her 1925 book *Carmel at Work and Play*: "most of the houses look as if they had grown into their surroundings as naturally as the pines. Little low redwood cottages snuggle in among the silver green trunks of oaks, they hide back of masses of wild lilac, or peep out over the tops of quaint, moss-flecked wooden palings." (Linda Lachmund Smith collection.)

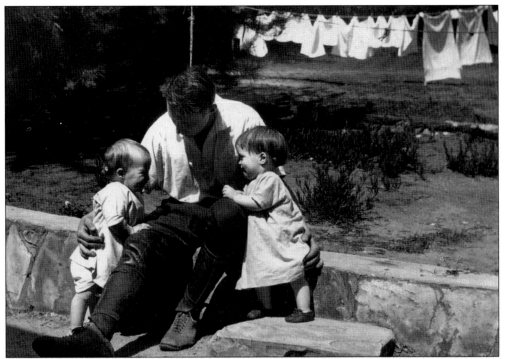

Robinson Jeffers and his wife, Una, had moved from the little log cabin to Trethaway House in 1916, when their twin sons Garth and Donnan were born. Here Jeffers, home taking a break from helping with the construction of Tor House on Carmel Point, is sitting in the garden of the rented cottage, playing with his two boys, who were barely a year old. (Tor House Foundation Collection.)

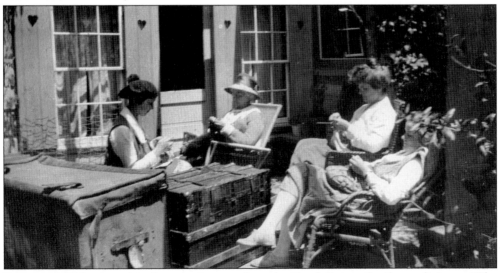

By around 1918, when this photograph was taken, the Frank Powers family was living at "The Dunes" year-round, and Jane Powers's mother, Clemenzie Rhodes Gallatin, was visiting often. Here she is sitting in the center of the patio, with a couple of family friends and her granddaughter Polly at right. They are all intently knitting, possibly for a World War I Red Cross project. (Erin Gafill collection.)

Mabel Phelps Campbell, pictured with her son John in 1915, arrived with her husband, Argyll, from San Jose in 1914. Argyll became Carmel's city attorney and helped to protect the character of the village by drafting a key ordinance whereby "The City of Carmel-by-the-Sea is hereby determined to be primarily, essentially and predominantly a residential city." (Photograph by S. L. Slevin; courtesy Lloyd family collection.)

Devendorf believed that people of aesthetic taste would settle in the naturally beautiful town of Carmel and, given certain constraints, would not mar that beauty unnecessarily. He and Powers made a conscious choice to price and size the lots affordably to the average wage earner, and they encouraged families with children. Small cottages with a tent for extra sleeping capacity, like this one, were common starter homes. (Harrison Memorial Library Collection.)

When this photograph was taken around 1911, Carmel had only 375 houses. In those early days, neighbors were few and far between, as this picture illustrates. This lady is looking down San Carlos Street, which was wide and unpaved. Behind her, visible at the far right, is the first Sunset School. (Carmel Heritage Society Collection.)

As the village grew, the area near the central business district developed, but Frank Powers reserved nine acres for himself and his family down by the beach, below San Antonio Street and Fourth Avenue. He planned larger lots for more substantial houses just to the east, along the border of Pebble Beach. Pictured here along the sandy drive to the home in 1917, Frank's two grandchildren, Lolly and Elizabeth Ulman, are watched over by a family friend. (Erin Gafill collection.)

The sand and mud along Ocean Avenue and other Carmel streets were a problem. Prior to the formation of the Carmel Development Company, the Women's Real Estate Company had a wooden sidewalk installed down Ocean Avenue all the way to the beach. Improvements like this made it easier to keep the white, starched summer dresses clean, as in this *c.* 1908 view on Ocean Avenue. S. L. Slevin's store is in the distance. (Erin Gafill collection.)

Maude May stands on the little bridge across Pescadero Canyon. Note the artistic railing pattern; small pine logs with the bark still on it were used. Pescadero Canyon forms the border between Carmel and Pebble Beach, where an exclusive, gated development was already underway by 1912 when this photograph was taken by S. L. Slevin. (Harrison Memorial Library Collection.)

Three

BUSINESS IN THE HEART OF THE QUAINT VILLAGE

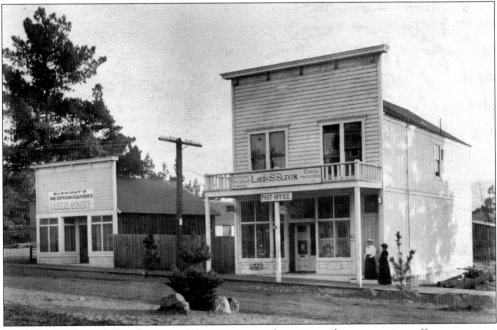

In 1903, the Carmel Development Company opened a store and a contracting office to support the new residents. The year before, Mrs. Slevin and her two sons, Louis and Joseph, had built their home on Carmelo Street. That fall, they bought a lot for $325 on Ocean Avenue, where Louis built his general merchandise store. Louis Slevin became Carmel's first postmaster and express agent and also served as the first city treasurer. When he was ordering lock boxes for mail customers, he found that the minimum order was eight boxes, and he became terribly worried that he would have too many. Before he knew it, he had to reorder, as the village grew rapidly with the influx of refugees from the 1906 San Francisco earthquake and fire. Pictured here, next to Louis L. Slevin's store and post office, is the little home bakery that became Thomas Burnright's Bakery and Candy Store in 1910. (Photograph by S. L. Slevin; courtesy Harrison Memorial Library Collection.)

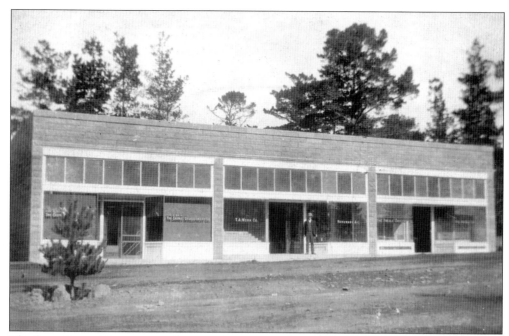

The first substantial permanent business structure in Carmel was built on the northwest corner of San Carlos Street and Ocean Avenue. Pictured around 1910, from left to right, are the Carmel Development Office, the T. A. Work Company and Hardware Company, and the Preble Grocery. This building stands in the same location today. (Jane Galante collection.)

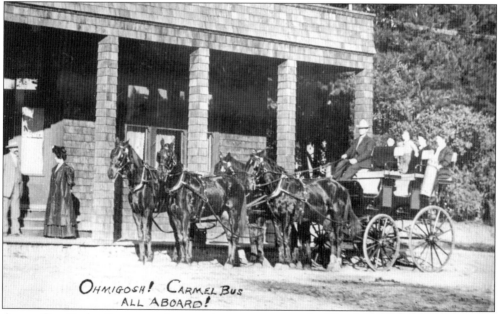

Across San Carlos Street on the same intersection was the Hotel Carmel, built in 1895 by D. W. Johnson. Here owner-operators Dr. A. A. Canfield and his wife are standing at the entrance as his "Tally-ho" stage arrives with hotel guests from the depot in Monterey. At the reins of the four-horse team is driver James Machado. The hotel burned to the ground in July 1931, in a spectacular fire. (Harrison Memorial Library Collection.)

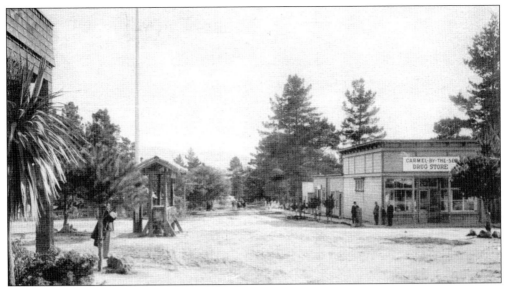

In this c. 1908 photograph, the Carmel water trough and the village flag pole are on the left. They stood for years in the middle of Ocean Avenue, side by side in front of the Hotel Carmelo. Across the street is the Carmel-by-the-Sea Drug Store. Road maintenance was a neverending chore. The men standing outside the store are watching the progress of the two-horse-team road grader that is coming up San Carlos Street. (Harrison Memorial Library Collection.)

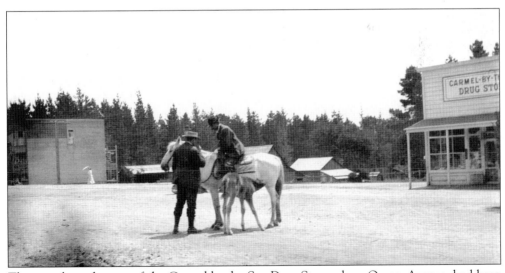

The parcels to the east of the Carmel-by-the-Sea Drug Store, along Ocean Avenue, had been among the very first lots sold by Devendorf and Powers to Mrs. E. A. Foster from Michigan. She was the first African American person to live in Carmel. In this c. 1906 photograph, the horse and rider are followed by the mare's foal, stopping in the intersection to let the little one have a drink. (Linda Lachmund Smith collection.)

Shortly after the Hotel Carmelo was moved, the Coffey brothers built a livery stable on the site shown in this *c.* 1908 photograph; the barns and stable are visible on the right. Although the right-of-way had been cleared early on, the maintenance of Ocean Avenue and the wooden sidewalk started at Junipero Street. Devendorf had his Japanese crew plant pine trees in the median, visible here. The vacant lot beyond the stable would become Devendorf Park. (Pat Hathaway Collection.)

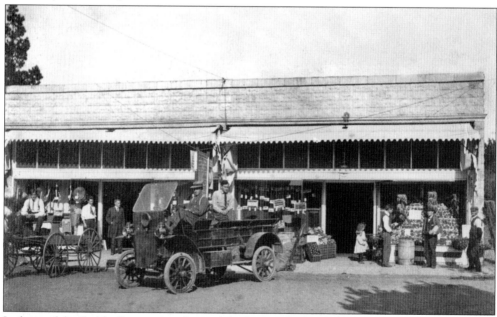

In front of the Preble Grocery are three of the four Leidig brothers who had come to Carmel as boys and later operated a grocery store. In operation at this location by 1914, the store soon offered home delivery. On the left, Robert Leidig stands in the door of Holman's Carmel store. Fred sits in the back of the truck. The buggy and truck parked side by side in this *c.* 1910 photograph are evidence of a transition in transportation modes. (Pat Hathaway Collection.)

Photographed in 1904 at their fix-it shop on Dolores Street, John Mikel (left) and Henry Larouette (right) had the reputation of being able to fix anything. Mikel's dog Fritz watches the world go by from his perch. Once a hill, the area was eventually leveled when Seventh Avenue was graded. Glen Leidig remembers the fun he and his brother had when they ambushed the workmen with water balloons from the top of the 12-foot road cut. (Harrison Memorial Library Collection.)

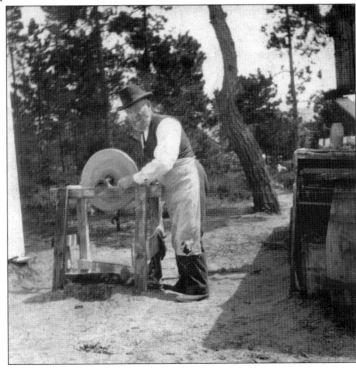

Devendorf was always on the lookout for new services to bring to Carmel. Early on, he persuaded relative John Staples to lend him a hand. Uncle John, hard at work here in 1904 sharpening his tools, was a jack-of-all-trades who operated as a repair and handyman from his cottage and workshop, which he had set up under the pines on a Devendorf parcel at Lincoln Street and Fifth Avenue. (Jane Galante collection.)

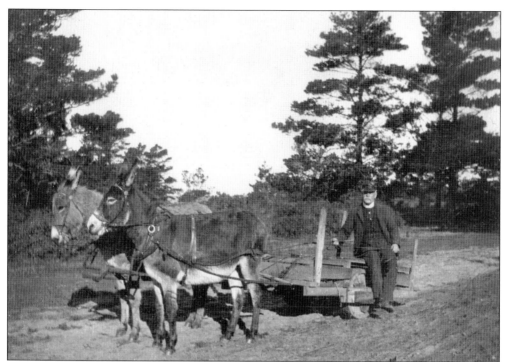

Dr. Peake, who arrived in Carmel around 1903, was a welcome addition, well liked and respected for his great knowledge of herbal medicine. He became Carmel's herb doctor. Pictured in this early photograph, he is making his rounds with his donkey cart. (Harrison Memorial Library Collection.)

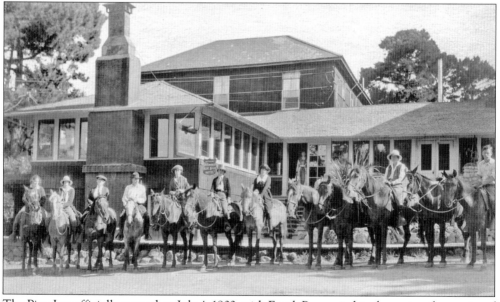

The Pine Inn officially opened on July 4, 1903, with Frank Powers in his element as the master of ceremonies. In 1921, the inn was accredited as an official Automobile Blue Book hotel. Gathering in front is the Wilson-McConnell riding party, setting out on June 11, 1921, for Big Sur. The ride to their destination at Turner Creek took them all day. (Harrison Memorial Library Collection.)

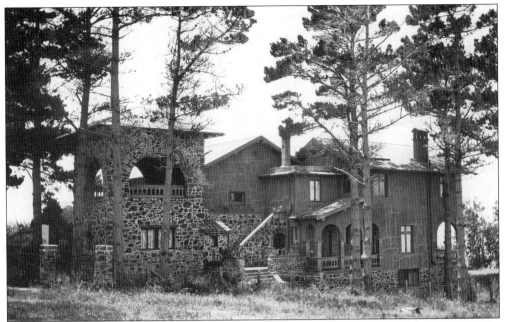

This home and studio, pictured around 1915, was built in 1904 for painter Chris Jorgensen. His wife, a member of the Ghirardelli chocolate family of San Francisco, was an avid swimmer, so the luxurious home featured a swimming pool. Jorgenson left for Yosemite in 1911, after his wife drowned while swimming in Carmel Bay. The enlarged building opened as the La Playa Hotel in May 1921. In the 1930s, rates were $5.50 per night, with meals included. (Harrison Memorial Library Collection.)

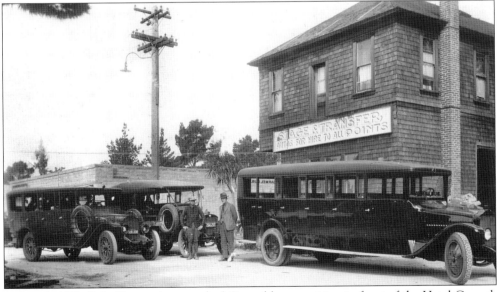

In March 1923, S. L. Slevin photographed Carmel buses waiting in front of the Hotel Carmel. Charles Gould, the next owner of the hotel, continued the tradition of using that location as a stage stop. He put up a sign: "Stage & Transfer: Autos for Hire to all Points," and bought the first two 16-passenger, motorized buses in 1912. Carmel Hill proved so daunting that buses and automobiles backed up the steepest part to top the grade. (Pat Hathaway Collection.)

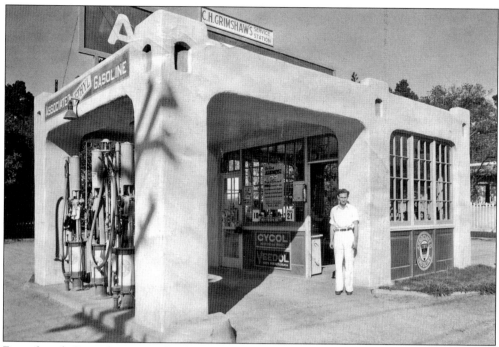

Even though Carmelites wanted to keep major progress from despoiling their village, cars were here to stay. In 1931, when this photograph was taken, a number of gas stations served the growing automobile population. Grimshaw's Flying A station was located on the northeast corner of San Carlos Street and Sixth Avenue. Here Arnold Grimshaw poses beside his business. (Harrison Memorial Library Collection.)

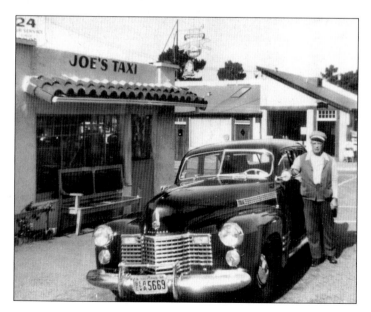

Carmel had public transportation from the start, but there was room for improvement, and this created an additional business opportunity. This 1948 image shows Joe's Taxi on the southeast corner of Dolores Street and Sixth Avenue. Owner-operators Joe Oliveria and his wife, Nellie, advertised 24-hour service. Joe, who only drove black Cadillacs, is pictured standing next to one of his taxis. (Harrison Memorial Library Collection.)

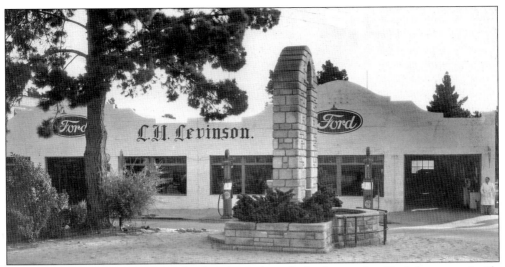

In 1930, Louis Levinson opened the first Carmel car dealership, with a Ford showroom inside his garage and gas station that he operated in conjunction with the Monterey Ford dealership. Parts manager George Moriarty is probably standing by the doors in this 1930 view. Pumps had been installed for the two grades of Red Crown gasoline sold here. Across San Carlos Street, Levinson built a facility to wash and detail cars. (Photograph by Lewis Josselyn; courtesy Pat Hathaway Collection.)

The Bank of Carmel was founded in 1923 and, in 1937, moved to a new building on Ocean Avenue and Dolores Street, across the street from Robert and Isabel Leidig's property. Their commercial building housed businesses on the ground floor and a spacious apartment upstairs. Here is granddaughter Susan Draper, pictured in 1952 on their large terrace. The 50-year-old pines growing down the middle of Ocean Avenue give the setting a tree-house effect. (Susan Draper collection.)

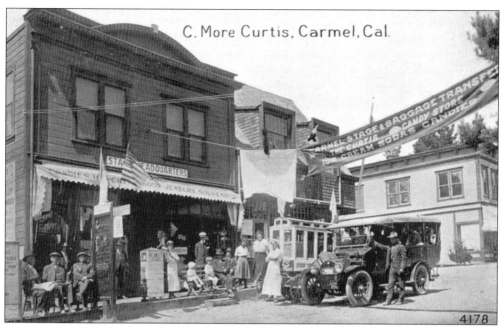

C. More Curtis, Carmel, Cal.

4178

C. M. Delos Curtis opened his store in 1912. Candy, ice cream, sodas, jewelry, and souvenirs were advertised on the awning when this photograph was taken in 1924. Curtis is shown in his long white apron, leaning against the popcorn wagon. He shared advertising on the large banner, mounted across the street, with the stage transfer stop. Passengers, like those shown here in the Carmel bus, would know just where to buy their souvenirs. (Photograph by S. L. Slevin; courtesy Harrison Memorial Library Collection.)

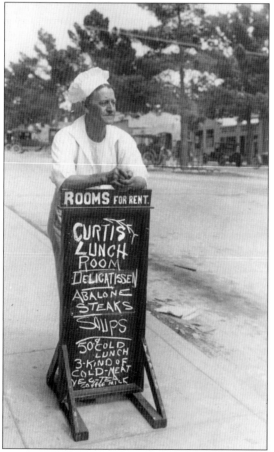

The Curtis store was a popular local gathering place. Much community business was transacted in informal meetings, as many businessmen and women were active in civic affairs. Pictured around 1918, Curtis takes a break from candy making and cooking. He is leaning on his chalkboard, which lists Curtis Lunch Room offerings such as abalone steak, soups, delicatessen, and a cold lunch for 50¢. (Photograph by S. L. Slevin; courtesy Harrison Memorial Library Collection.)

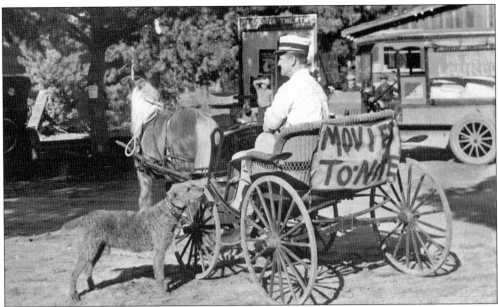

Carmel's first silent movies were shown at the Manzanita Theater in 1916. Curtis acted as manager, sold the tickets, and provided popcorn. When a film was available, he would hitch up his pony, Peanuts, and drive around town with a large sign reading "Movie Tonight" fastened to the back of his cart. Tickets were 10¢. When he had sold enough to fill the barn, he would start the show, first making sure that the little children had a seat in the front row. This image was taken in 1927. (Photograph by S. L. Slevin; courtesy Harrison Memorial Library Collection.)

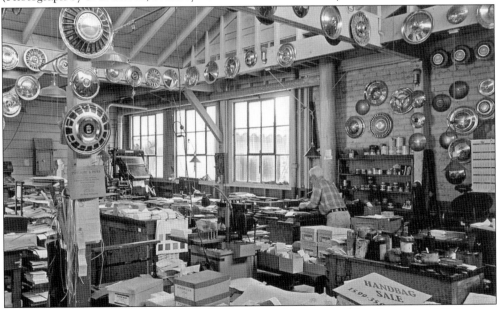

In 1937, when Howard Timbers came to work at Carmel Press, it was the place to be. All the town news was disseminated here, where the *Carmel Cymbal* and *Maston's Gazette*, the forerunners of the *Carmel Pine Cone*, were printed. Alan McEwen took this photograph in 1982, just before Timbers retired after 45 years at the press. As he bicycled to work from his Carmel Woods home, Timbers collected the hubcaps that decorated his workshop. (Alan McEwen collection.)

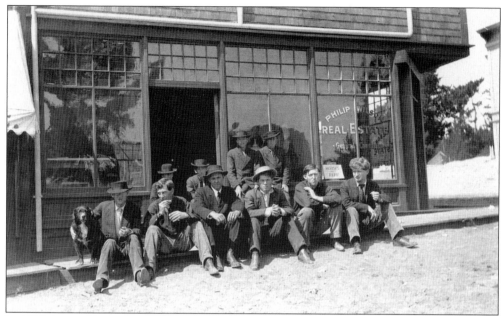

In 1906, Jimmy Hopper meets up with some of his friends and their dog on the wooden sidewalk in front of Philip Wilson's real estate office on Ocean Avenue and Dolores Street. Cottages sold for $500 each, or $50 per residential lot, with terms of $5 down and $5 per month. Ten years later, in 1916, this building would be used as the first "official" city hall. (Linda Lachmund Smith collection.)

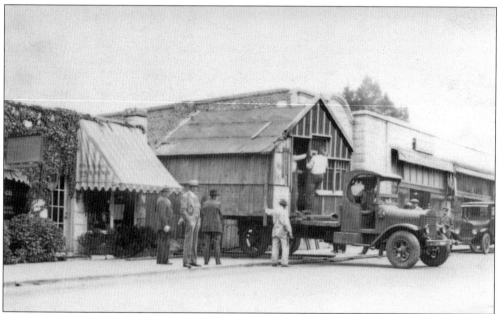

Another much-needed service was provided in 1906 when C. J. Arne opened his barbershop in a tent on Ocean Avenue. It served him until the first Bank of Carmel was constructed there in 1923. The shop moved into a little vine-covered, board-and-batten cottage a few feet from its old location, right next to Walker's Shoeshine. In this 1928 photograph, Frank Devendorf (left) watches as M. J. Murphy moves the cottage. (Harrison Memorial Library Collection.)

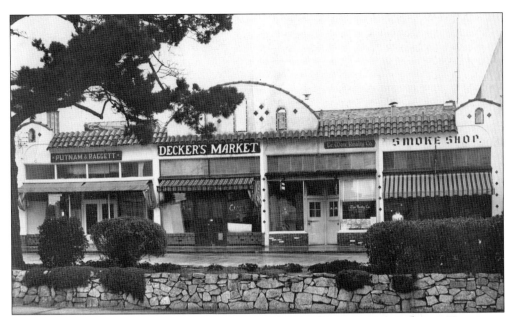

This photograph, taken shortly after World War II, depicts the many resident-oriented businesses along Ocean Avenue. Pictured, from left to right, are Putnam and Raggett, Decker's Market, Le Mon Realty, and the Smoke Shop. Frank Putnam and Mark Raggett had bought F. R. Meagher's dry-goods store and opened what became "the closest thing to a department store" in 1946. Nylons were the hottest item right after the war. Successful with their friendly service and popular merchandise, they soon expanded into Decker's Market. (Raggett family collection.)

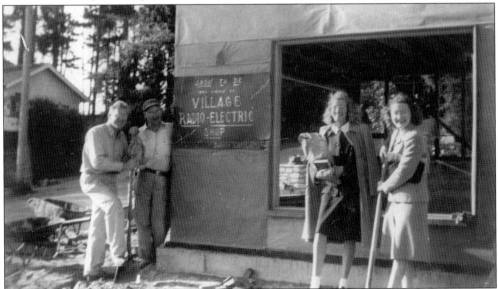

In 1945, Barney Laiolo moved his family into the former R. B. Stoney house above Fourth Avenue on Mission Street. Here, shovel in hand, he builds a shop on his property for his electrical and locksmith business. His sense of humor shows in his identification of the two women in this photograph as "building hazards." Barney's love of people, music, theater, and politics soon drew him into community affairs. He became the first popularly elected mayor in 1980. (Laiolo family collection.)

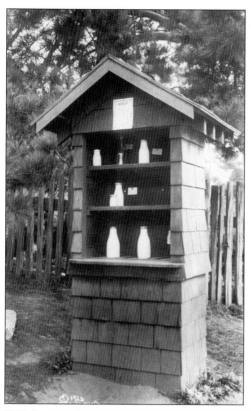

The Carmel Dairy started operations in 1903, with milk from the Mission Ranch and the Hatton Dairy at the mouth of the Carmel Valley. By 1916, Perry McDonald opened the first commercial dairy and established the custom of milk shrines. Every second block had one of the little structures, like the one shown here in 1923, clearly identified as the property of the Carmel Dairy. (Photograph by S. L. Slevin; courtesy Harrison Memorial Library Collection.)

The milk shrines had notes with the names and daily customer orders tacked to the back wall. The residents would leave the empty bottles, money, or milk tickets on the shelf at night, and in the early morning, the driver would leave the orders. Pictured here are probably the only surviving milk orders, left by cartoonist Hank Ketchum, who lived in Carmel in 1947 with his wife and son, the real "Dennis the Menace." (Pat Sippel collection.)

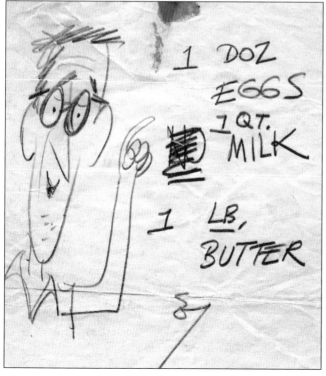

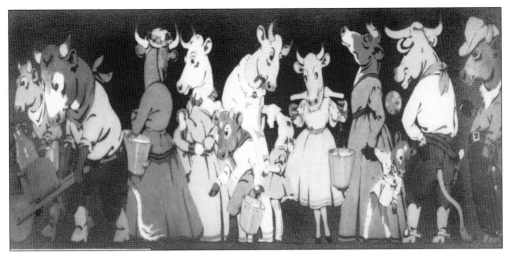

Eventually Earl Graft combined the smaller dairies and operated his business for 27 years on the corner of Ocean Avenue and Mission Street. Local artist Jo Mora designed a cow that served as the logo on the milk bottles and on the popular lunch menu at Earl's delicatessen. His wonderful mural of cows working and socializing decorated the interior. The mural remained even after the Mediterranean Market took over the site. (Harrison Memorial Library Collection.)

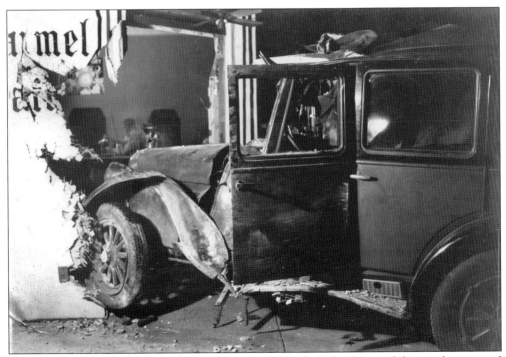

The Carmel Dairy had an unwelcome visitor in 1933 when the driver of this car lost control and entered the store by an unauthorized route—straight through the wall—doing considerable damage to his car and the store. Some uncharitable souls speculated that the beverage of choice might not have been milk. (Pat Sippel collection.)

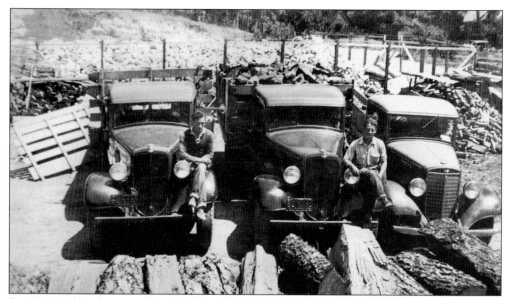

In 1909, Fred Leidig started Leidig's Wood Yard. He employed men from Carmel's "Tortilla Flat" area to cut and split firewood. However, by the 1930s, there was room for competition, and Keith Evans, who moved here from Australia, opened Plaza Fuel Company. This late-1930s photograph was taken of his yard, with drivers Henry Morales and Everett Gregory sitting on the fenders of their Chevy trucks. (Virginia Evans collection.)

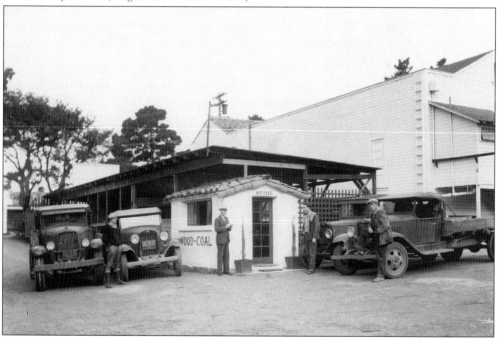

Plaza Fuel Company advertised wood, coal, kindling, and mill floors. It was located up Junipero Street, next to the stables visible at right. When this 1930s photograph was taken, it had become the San Carlos Riding Academy and was operated by Lynn Hodges. In front of his Plaza Fuel office is owner Keith Evans, with a clipboard that probably held the day's orders for the waiting truck drivers. (Pat Hathaway Collection.)

Carmel had three talented blacksmiths, all of whom eventually became deeply involved in the politics of the village and served as mayors. Their work can still be seen on many of the Mediterranean-style buildings in town. In this photograph from 1932, John Catlin stands at left, hammer in hand, in front of his Forge-in-the-Forest. Next to him is Keith Evans, who became his partner that year. (Virginia Evans collection.)

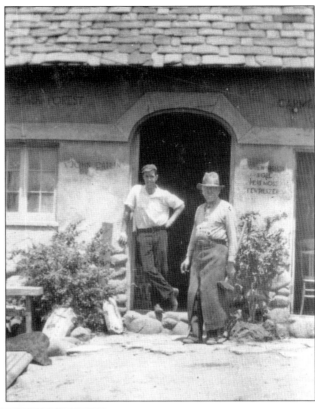

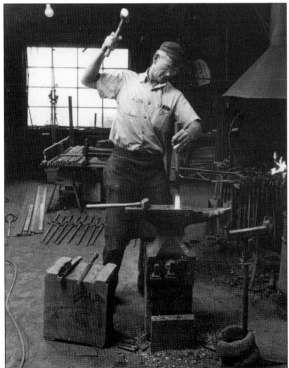

Around 1950, Francis Whitaker is hard at work at his anvil. He came to Carmel in 1923 as a trained journeyman, directly from the famous Samuel Yellin Metalworks of Pennsylvania. He worked for M. J. Murphy and with John Catlin. After the property changed hands, he built a new Forge-in-the-Forest across Junipero Street. Today his old workshop houses a restaurant. (Photograph by Wynne H. Hutchings; courtesy Sheila Hutchings collection.)

49

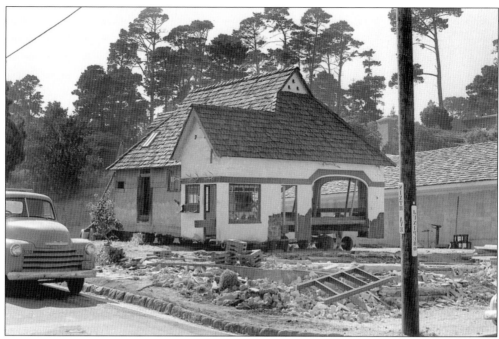

The old Forge-in-the-Forest building, which had fronted Junipero Street for almost 50 years, was moved to the back of the lot by M. J. Murphy and his crew in 1956. The dovecote is clearly visible in the gable of the roof where Catlin and Evans were raising their white birds. Today the building is home to the Surf and Sand drugstore behind Bruno's Market, one of only two remaining grocery stores in Carmel. (Photograph by Arthur McEwen; courtesy Alan McEwen collection.)

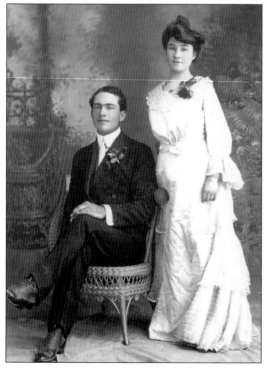

Michael Murphy, pictured here in 1904 with his bride, Edna, is an example of what could be achieved with the encouragement and opportunity Devendorf and Powers extended to people who wanted to help build this special community. A bright and talented young man, Murphy started out with a wagon and a team of horses that grew into a business that would literally build much of Carmel. (M. J. Murphy collection.)

Four

BUILDING
AND PRESERVING
A UNIQUE COMMUNITY

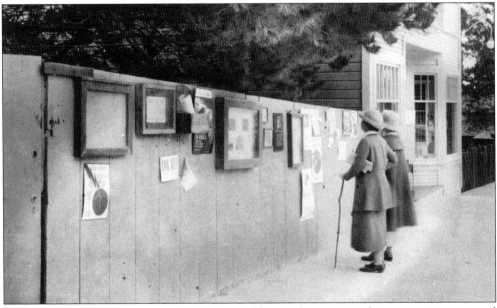

Early Carmelites recognized that the key to building and preserving the community was good communication. A number of weekly newspapers served as sounding boards for ideas, carried advertising, and kept citizens abreast of town events, but the bulletin board filled a special need. Anybody could put up a notice on the old board fence, free of charge. Residents, like the two women pictured here around 1920, on their daily visit to pick up the mail at the post office and catch up on the local news, would go out of their way to check the board. Perhaps they would find that a club gathering had been postponed, an interesting object was offered for sale or trade, or a neighbor had lost a puppy. The bulletin board was forced to move many times as the business district grew. Today it is a shadow of its former self, located on Dolores Street near the post office. (Harrison Memorial Library Collection.)

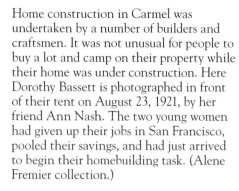

Home construction in Carmel was undertaken by a number of builders and craftsmen. It was not unusual for people to buy a lot and camp on their property while their home was under construction. Here Dorothy Bassett is photographed in front of their tent on August 23, 1921, by her friend Ann Nash. The two young women had given up their jobs in San Francisco, pooled their savings, and had just arrived to begin their homebuilding task. (Alene Fremier collection.)

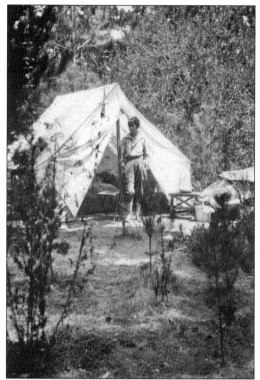

Dorothy and Ann started right in mixing concrete by hand, "like a recipe" (below left). A week later, Ann, keeping a detailed diary, photographed Dorothy planing redwood (below right), with the board-and-batten siding visible in the background. They had help with the framing, plumbing, electrical, masonry work, and felling some trees. By November, they moved in, and two years later, when they finished the house, they had spent a total of $1,045. (Alene Fremier collection.)

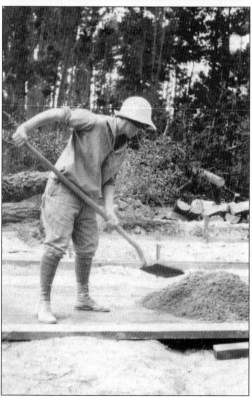

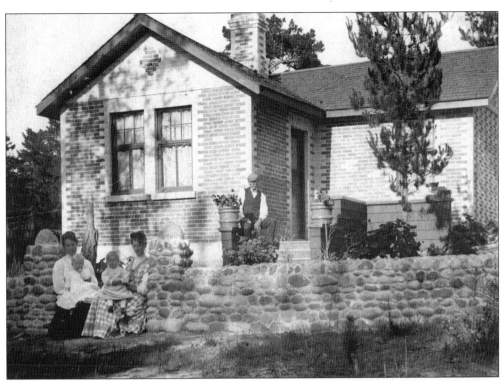

Another do-it-yourself builder was Ben Turner, who put up the first brick house in Carmel, pictured here around 1907. A skilled stonemason, Turner's workmanship was in great demand. Here he is in front of his brick home on Monte Verde Street, between Fifth and Sixth Avenues. His daughter Emma, with her baby Marian, and Elizabeth Aucourt and her baby Dorothy are sitting on the steps. (Harrison Memorial Library Collection.)

Robert Gillett and his family, pictured here in 1916, came to live in Carmel in 1913. Robert was a building contractor associated with M. J. Murphy for a time. When Devendorf developed the Carmel Highlands, he hired Gillett to build the Highlands Inn. Standing outside their 10-year-old cottage on San Carlos Street and Ninth Avenue are, from left to right, (first row) twins Andrew and Thomas; (second row) Robert, Margaret, Idena, and Eugene. (Photograph by Lewis Josselyn; Lloyd family collection.)

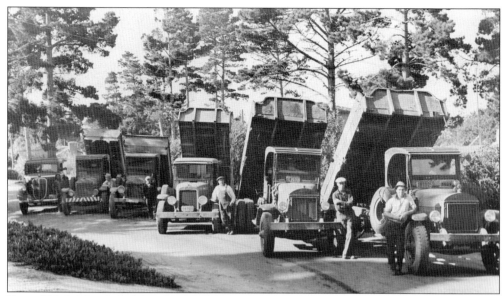

Part of M. J. Murphy's fleet of trucks lines up in 1942 near his lumberyard at Mission Street and Seventh Avenue. From 1933 to 1937, when Highway 1 opened, Murphy supplied much of the material and labor for the construction of the northern portion of the road from Carmel to San Simeon. His drivers, from left to right, are Manuel Vierra, George DeRose, Joe Goodrick, Louis Davidson, Lloyd Younkin, and Joe Nicholson. (Photograph by George Smith; courtesy M. J. Murphy collection.)

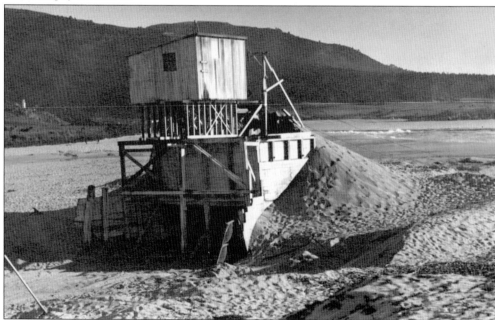

Murphy built his sand plant on the beach at the mouth of the Carmel River. Kai Miamoto operated the sand scoop for him. The shovel was attached to cables so the sand could be dragged up into the hopper. The plant became a draw for local teenagers, the perfect place to meet and play, away from town. During one of these gatherings, about 1948, a campfire got away and burned the plant down. (Photograph by George Smith; courtesy M. J. Murphy collection.)

This is a 1930 view of the original Carmel Hospital that opened its doors in September 1927. Mrs. Edith Shuffelton, a nurse from Stanford, had convinced local residents to finance the facility, which was built on her Carmel Woods property. Later it served as the Forest Lodge and for a short time as the Convalescent Annex of the Community Hospital. It has been a private residence since the late 1950s. (M. J. Murphy collection.)

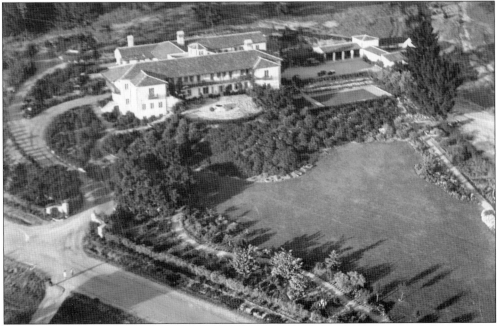

The first Community Hospital is pictured in this 1949 aerial photograph, originally built in 1929 as the Grace Deere Velie Metabolic Clinic on Highway 1 and Valley Way. Grace, an heiress to the John Deere tractor fortune, suffered from an incurable disease. She helped finance the hospital. Many a Carmel child was born here before 1963, when it was turned into the Carmel Convalescent Hospital. M. J. Murphy built both hospitals in the popular Mediterranean style. (Harrison Memorial Library Collection.)

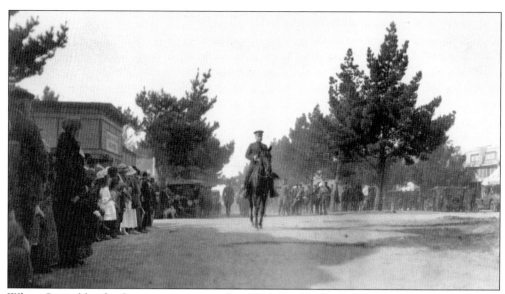

When Carmel-by-the-Sea was incorporated in 1916, Gus Englund was sworn in as city marshal. He is pictured here in 1921 riding in a Veteran's Day parade. In his native Sweden, he had served with the King's Dragoons and was well suited as a one-man police force, making arrests, returning lost pets and children, lighting oil stoves, and giving directions. He was a familiar and comforting sight on his big black horse, Billy. (Photograph by Lewis Josselyn; courtesy Harrison Memorial Library Collection.)

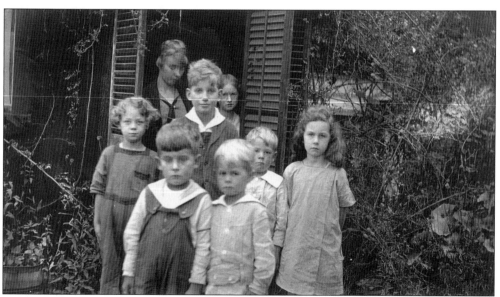

Devendorf realized that a school was the key to having a permanent community with year-round residents. With seven school-age children by 1903, he arranged for a teacher, and public-school classes commenced in Delos Goldsmith's old shed. Whether a child went to a public or private school, such as Forest Hill or Miss Williams's, great emphasis was put on artistic expression. Pictured here in 1916 are Miss Williams and her students, including David Lloyd and Billy Heron. (Harrison Memorial Library Collection.)

Public-school enrollment grew to 18 by 1905, requiring a larger room. M. J. Murphy made space available at his lumberyard. In 1906, the first Sunset School, pictured here c. 1915, opened on the southeast corner of San Carlos Street and Ninth Avenue. The little town grew rapidly, and that year, the two-room school had 48 students in eight grades. By 1926, it was replaced by the "new" Sunset School, which has served as Carmel's cultural center since 1965. (Harrison Memorial Library Collection.)

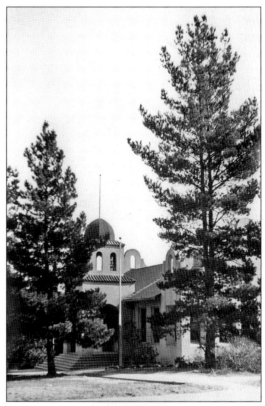

The modest "Carmel Library" sign on this cottage documents the beginning of the library movement in 1904. The next year, Frank and Jane Powers led an active group who formed the first free library. Ella Reid Harrison left an endowment to construct the Harrison Memorial Library, built in 1921 by M. J. Murphy. Today an annex houses the children's library and the Henry Meade Williams Local History Department, a repository of research materials about Carmel. (Harrison Memorial Library Collection.)

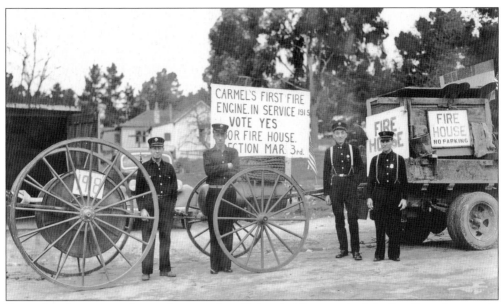

To combat the extreme threat of summer fires, Robert Leidig organized the first fire volunteers in 1908, and in the summer of 1915, they purchased their first fire engine. It was paraded up and down Ocean Avenue for residents and donors to admire. Then the group officially organized themselves as Carmel Chemical Company No. 1. Pictured here, from left to right, are E. Walls, D. Machado, B. Adams, and R. Leidig posing behind the firehouse in 1936. (Pat Hathaway Collection.)

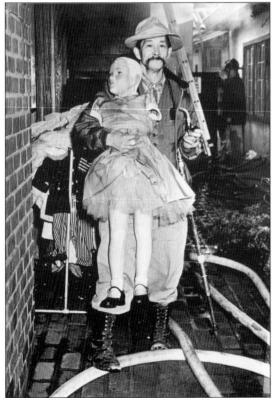

Pon Lung Chung came to Carmel in 1920 and became the unofficial village night watchman. Responding to every fire, in 1924 he became an official member of the Carmel Volunteer Fire Department. Reportedly he never missed a blaze during 41 years in Carmel. Pon remembered that the first equipment was kept in a makeshift tent on San Carlos Street and Sixth Avenue. He is pictured here in 1955, "rescuing" a mannequin. (Photograph by Alan McEwen; courtesy McEwen collection.)

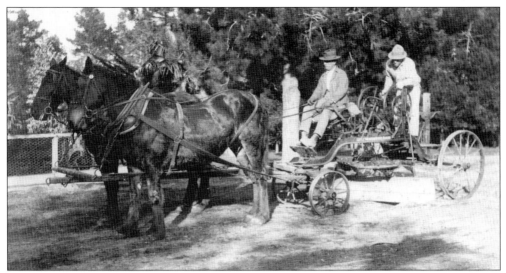

All village roads were either sand or dirt, and, with the increasing traffic, road conditions were often terrible. Regular street grading helped. The road grader, drawn by a two-horse-team operated by M. J. Murphy's crew, is pictured here in 1920. The teamster on the left guides the horses, while the man on back adjusts the blade's depth with the two large wheels. The mechanism above the blade set the angle. (M. J. Murphy collection.)

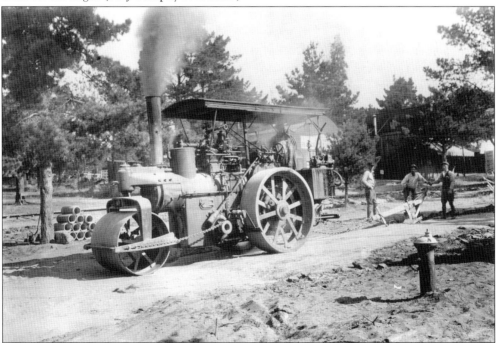

Old-timers remember Ocean Avenue as a dusty road full of holes, ruts, and gullies. Some of the worst bumps were known by name: "Devil's Staircase," "The Witch's Caldron," and "The Hinges of Hell." After a heavy rain, the holes could be four to five feet deep. A way of life was threatened, and many villagers protested the paving of the road, hoping to hold back the future. Men and equipment were finally at work when this photograph was taken in 1922, and Ocean Avenue was paved. (Harrison Memorial Library Collection.)

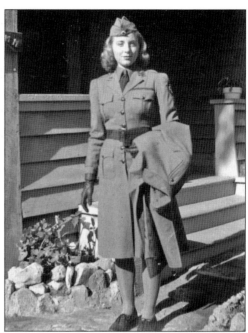

During both world wars, many young Carmel women volunteered to go through training provided by the Red Cross. Frank Powers's daughter Polly is pictured at left in 1918, wearing a nurse's uniform. During World War II, Kay Hamm (Prine) worked at Fort Ord as a WOW (Woman Ordinance Worker). Her weekends were spent attending classes at American Women's Volunteer Services learning to drive an ambulance. She is photographed here in 1942, wearing the AWVS uniform. (Erin Gafill and Harrison Memorial Library Collection.)

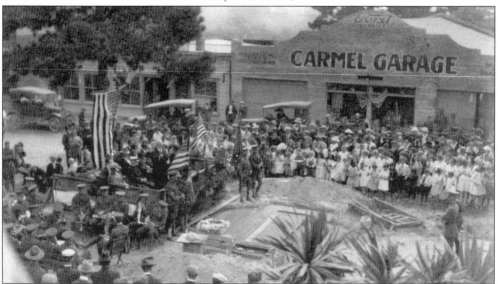

On November 11, 1921, ground was broken for the Veteran's Memorial Arch on San Carlos Street and Ocean Avenue, viewed here from the roof of the Hotel Carmel. Designed by architect Charles Sumner Greene, the arch commemorated 56 Carmel men who served during World War I. Originally Greene incorporated a drinking fountain, but fear of vandalism caused its removal in the 1960s. (Photograph by Lewis Josselyn; courtesy Harrison Memorial Library Collection.)

The sign in front of the Carmel USO, declared: "Open every day, except Mondays." During World War II, parties, dances, and plays were held here for servicemen and servicewomen stationed on the Monterey Peninsula. It was considered civic duty to help entertain the troops; never mind the fun. Pictured in 1944, from left to right, are PFC Vernon Lipps, Sylvia Thorn and her dog Thor, PFC Harry Warren, and PFC James McCartney. (Harrison Memorial Library Collection.)

During the war, the radio was important to everyone. Reported sightings of Japanese submarines and aircraft off the West Coast kept the population vigilant. The civil air patrol scanned the skies and soldiers patrolled the beaches. To provide some comfort, Carmel women delivered hot coffee to the beach night patrol at 11:00 p.m. A lighthearted moment, captured here in October 1943, finds this group of soldiers gathered around the radio in American Legion Hall. (Harrison Memorial Library Collection.)

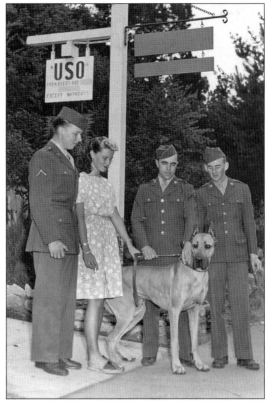

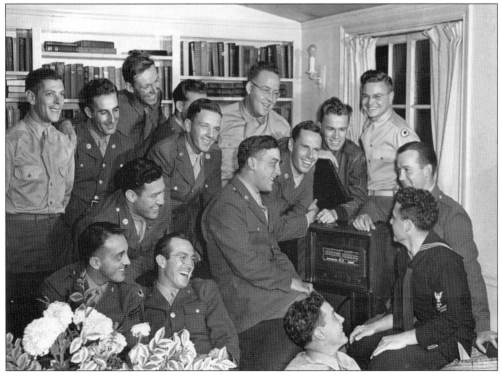

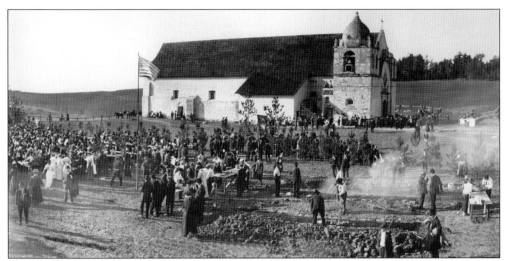

Always aware of residents' needs, Devendorf provided two lots on Lincoln Street and Seventh Avenue for a community church. The first services were held at the Hotel Carmelo. The Carmel Mission had been serving the Catholic parish from the beginning. This is a portion of a panorama taken by A. C. Heidrick on November 23, 1913. Approximately 3,000 people made the pilgrimage to the mission to commemorate the 200th anniversary of the birth of Fr. Junipero Serra. (Monterey Public Library Collection.)

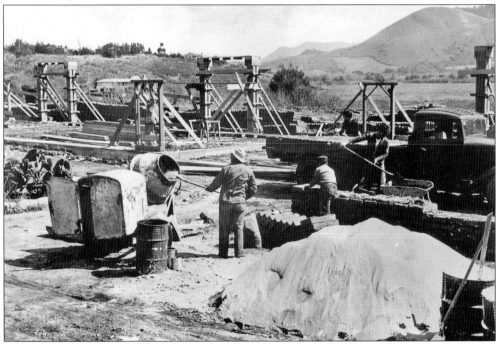

The renovation of the mission church started in 1936. The steep roof was replaced, restoring the Moorish-style architecture. Harry Downie, in charge of restoration, is pictured here around 1940, rebuilding the mission quadrangle. New adobe bricks were made on site using the material from the ruined adobe walls mixed with new sand, straw, and bitumen (a petroleum product). A heavy wooden framework was set up to help with the construction of the adobe walls. (Pat Hathaway Collection.)

The Carmel Mission has attracted visitors and dignitaries from all over the world, including Pope John Paul in 1987. He called it "the spiritual heart of California." Here, visiting in 1956, Pres. Dwight Eisenhower and First Lady Mamie Eisenhower are talking to Monsignor O'Connell. The stone construction is visible in the bell tower behind them. The round cupola of the bell tower is made of gradually decreasing rings of fired tiles, carefully laid to create the shape. (Monterey Public Library Collection.)

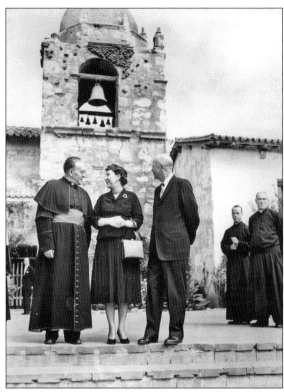

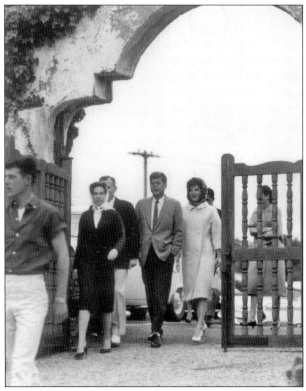

During John F. Kennedy's presidential campaign, he and Jackie took a break from the campaign trail. Here they are pictured entering the Carmel Mission on their way to Sunday Mass on May 29, 1960. California senator Fred Farr, who had been invited by Kennedy, brought along his 16-year-old daughter, Francesca. She remembers her father telling her, "He is going to be the next president of the United States." (Photograph by Arthur McEwen; courtesy Alan McEwen collection.)

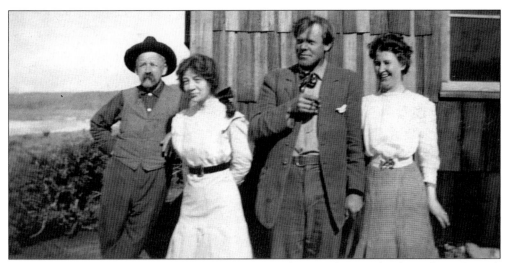

Carmel politics have always been lively, as business and artistic factions fought to shape Carmel. Perry Newberry, pictured here at center in February 1911, was a writer, artist, actor, director, musician, and dancer. He designed and built several houses and served as mayor and publisher of the weekly *Pine Cone*. When Perry ran for mayor, he urged his fellow Carmelites to "Keep Carmel off the Map." He was imaginative and tireless in the struggle against commercialization. (Harrison Memorial Library Collection.)

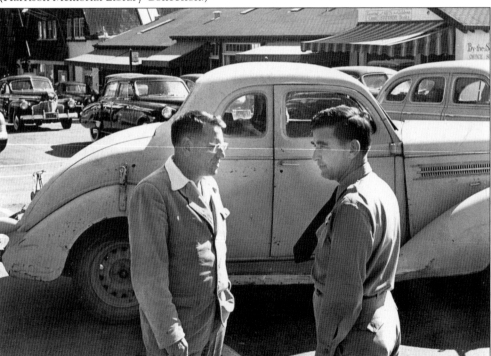

From the very beginning, villagers discussed community business when they were "up-town." That practice did not change with incorporation in 1916, and it was not unusual to see council members, merchants, and residents gathered in stores or on street corners, talking over problems. Here, in the late 1940s, Allen Knight, who was police commissioner, and Chief Freitas, are following that tradition. (Photograph by George H. Cain; courtesy Alene Fremier collection.)

With postwar growth and tourism threatening
Carmel, protective measures included no
glaring neon signs, no proliferation of large
motels and shopping malls, no large business
signs, and a "hold harmless" license to wear
high heels in town. The message was clear:
small, unobtrusive, and rustic were beautiful.
In a swing of the political seesaw, Clint
Eastwood was elected mayor in 1986. Pictured
here are campaign buttons, a first for Carmel.
(Alan McEwen collection.)

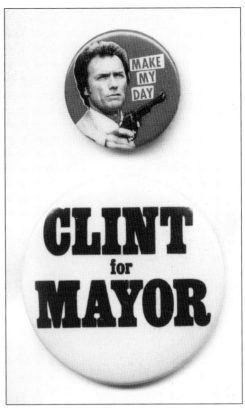

Eastwood, tired of the regulations that held
up his construction project, ran for mayor on
a cut-the-red-tape platform. He is pictured
here meeting with chief of police Clyde P.
Klaumann, and city councilman and police
officer Bob Fisher, at right. Dismayed Carmel
residents were deluged by the media from
Tokyo to London when Clint was elected. He
served for only two years, but 20 years later,
tourists are still arriving to see "Clint's town."
(Clyde R. Klaumann collection.)

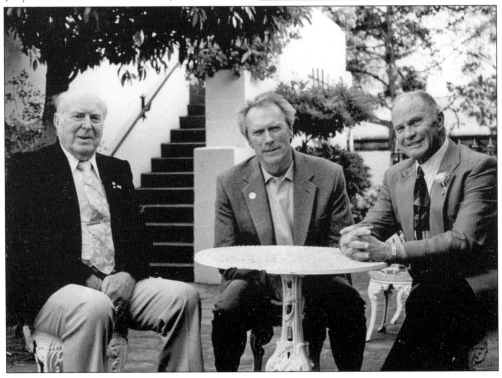

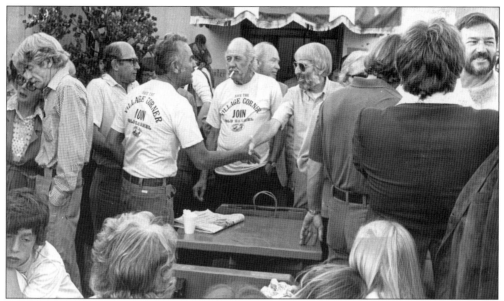

By 1976, rents and property values soared, and one of Carmel's favorite gathering places, the Village Corner restaurant, was scheduled for demolition to make way for more profitable stores. The prospect of losing yet another of its beloved "institutions" finally galvanized citizens into action. On August 27, 1976, at the Village Corner, "Old Carmel" was founded to bring about a change. Ben Lyon, Lacy Williams Faia, and Frank Lloyd signed the articles of incorporation. (Susan Draper collection.)

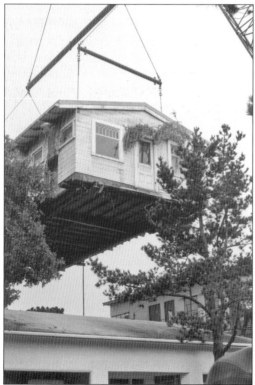

The Village Corner was saved with the cooperation of the Leidig heirs, and "Old Carmel" became "Carmel Tomorrow" and then "Carmel Heritage Society." In 1991, the first house M. J. Murphy built in 1902 when he was 17 years old had to go. The society was responsible for the move, pictured here, to its new location on Lincoln Street and Sixth Avenue, where it serves as the Carmel Heritage Society Welcome Center. (Carmel Heritage Society Collection.)

Five

GROWING BEYOND THE ONE SQUARE MILE

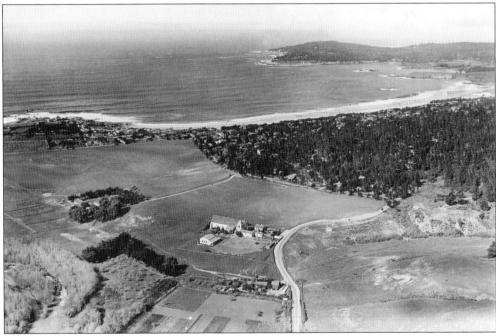

Carmel's two far-sighted founders, Frank Powers and Frank Devendorf, had bought all the land down to Santa Lucia Avenue, as well as the entire Carmel Point from the Martin family. If their development succeeded, it would grow far beyond the slope above the beach. They recognized the importance of owning the entire shoreline, as it would allow them to control the town's growth and make larger lots available without interfering with the village character. In this c. 1931 aerial view, the property line is clearly visible. With the coming of the automobile, the one-mile distance to town was no longer an issue. By now, many homes had been built and a canopy of trees reached Santa Lucia. The Carmel Mission and Martin Ranch properties are completely surrounded by open fields. (Photograph by Julian Graham; courtesy Pat Hathaway Collection.)

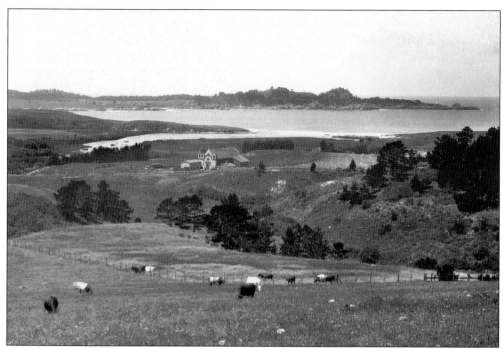

Looking down from the Hatton Fields across the Bay to Point Lobos, this is what the area looked like around 1921, before it was subdivided. Cattle from the Hatton dairy are grazing in the foreground. To the right of the mission church, a hay field is being harvested. Visible just beyond it is the roof of the Martin Ranch home. Because of its proximity to the mission, it was also referred to as the Mission Ranch. (Pat Hathaway Collection.)

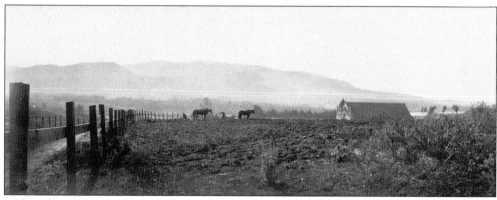

Although warned that the windswept land would not even support a potato crop, Scotsman John Martin acquired land in 1860. Nevertheless, he successfully grew potatoes and raised stock. Martin deeded some of his property that adjoined the ruined mission buildings to the church so that there would be access. When this photograph was taken around 1910, his stepson Andrew Stewart was running the ranch. The two teams plowing the earth above the church probably belonged to him. (Carmel Heritage Society Collection.)

John Martin returned to Canada in 1871 to bring his bride, the widowed Elizabeth Stewart, and her three young sons, to the ranch. When she expressed concern about the isolation, he assured her that she would live right next door to a "wee church." She did not know until she arrived that the church was an abandoned Spanish mission. She would have five more sons and one daughter, Isabel, who is pictured here at age 24 in 1908. (Susan Draper collection.)

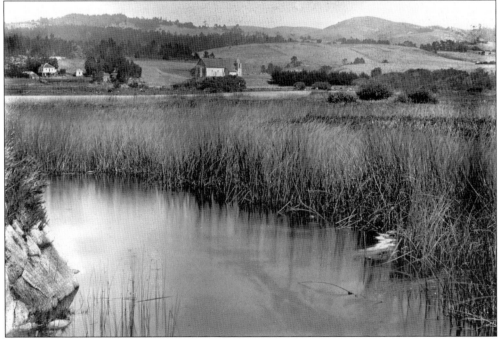

To this day, heavy Pacific Ocean surf builds up a high sand bar across the mouth of the Carmel River. This c. 1900 photograph shows how the river meandered and slowed as it approached the sea, spread out, and created a lagoon that filled like a large lake after heavy winter rains. On the high ground, on the opposite bank, are the Mission Ranch homestead and the mission church. (Pat Hathaway Collection.)

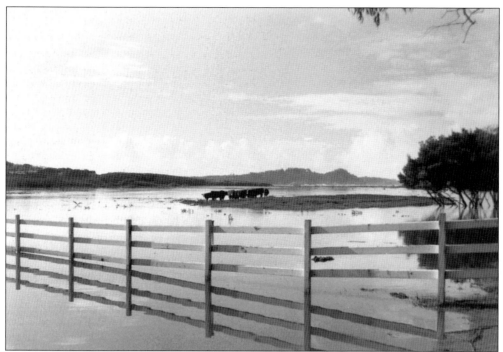

From the time of Fr. Junipero Serra, there is an account of Native American neophytes rowing him out on a lake near the mission, in a boat made from tules, or rushes. During Martin's tenure, it was not unusual for fields to flood, leaving livestock stranded on a bit of high ground. This photograph, taken in 1982, is a reminder that the right tide, surf, and flood conditions can happen again. (Photograph by Colin Kuster; courtesy Harrison Memorial Library Collection.)

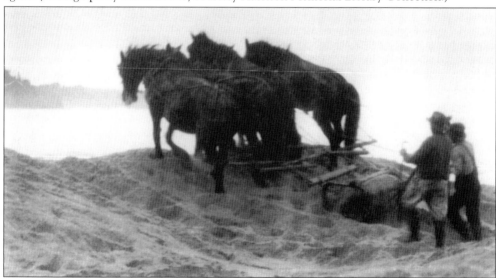

In this c. 1900 photograph, a three-horse team is dragging a scoop, used to create a low spot, so the river's mouth would open, decreasing the water level of the lagoon. As the land was subdivided and houses began to encroach on the wetlands, it was not unusual to see men take out their shovels to dig a ditch to get the river started, preventing their homes from flooding. (Monterey Public Library Collection.)

Many men who first saw the Monterey Peninsula while stationed at Fort Ord decided to return after World War II. The demand for affordable housing spawned Mission Fields, the subdivision built on what had been agricultural land and river flood plain. In 1958, reporter Jimmy Costello is pictured here standing in a washbasin in the Carmel River Inn phone booth while covering the "100-year flood" for the *Monterey Peninsula Herald*. (Photograph by Arthur McEwen; courtesy Alan McEwen collection.)

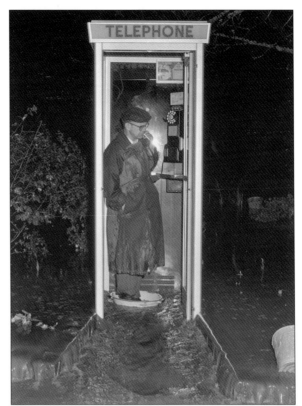

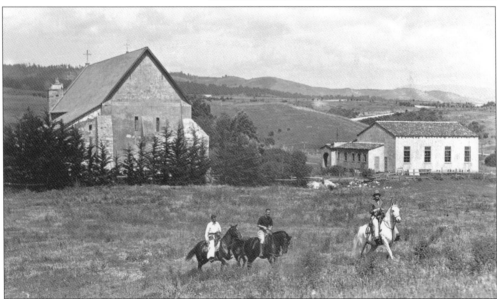

The 216-acre Mission Ranch, sold in 1926 to W. J. Walker for $150,000, transformed into the Valley Ranch Club. Along with converted dairy buildings, it sported an airstrip, swimming pool, and polo field, seen in this early 1930s view of riders in the field behind the mission and Crespi Hall. Live music came in 1937, and for years, "See you at the ranch" could only mean one place. (Photograph by Julian Graham; courtesy Pat Hathaway Collection.)

The Valley Ranch Club bunkhouse, pictured here in 1979, was built in 1852 and is the oldest Mission Ranch building. During World War II, the ranch also served as an officers club, the barns accommodating badminton, ping-pong, and dances. Local talent, including Mayor Barney Laiolo and his gutbucket, could be found at the restaurant piano bar. Clint Eastwood bought the ranch in 1986 when it was threatened by development, with the intention of preserving the landmark. (Photograph by Alan McEwen; courtesy Alan McEwen collection.)

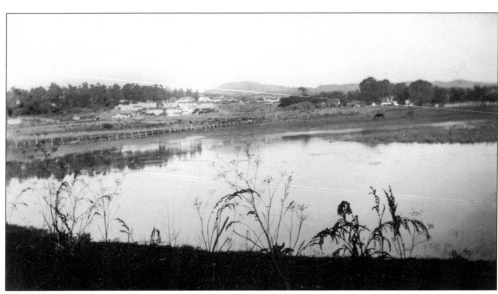

These are the first homes built on land known as the Walker Tract, between the ranch, at right, and Santa Lucia Avenue in 1939. Carmel River School was built just across the fence in 1946. In the years following World War II, Mission Ranch became the "swingiest place in California," frequented by celebrities like Frank Sinatra and Joan Baez. Parts of the movie *A Summer Place*, starring Sandra Dee and Troy Donahue, were filmed here in 1959. (Charis Buckminster collection.)

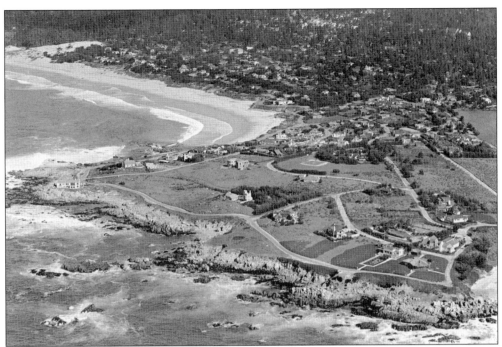

On Carmel Point, a number of early property owners bought several acres, built their homes, and later subdivided and sold adjoining lots. With no electricity, gas, or paved roads for many years, the Point was settled slowly. For example, in this c. 1925 aerial photograph, the Robinson Jeffers family, the Charles Van Ripers, the George Reamers, and Mrs. Wells had the Point practically to themselves. (Pat Hathaway Collection.)

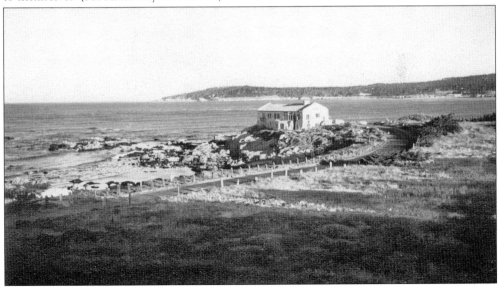

This large, two-story house, built by Colonel Dutton, was christened the "Warehouse" by neighbor Robinson Jeffers. It sat on a large property to the west of the "Sea Road," a dirt track that was marked by driftwood stakes on both sides. The house was demolished in 1955 to make way for a new home. The Monterey cypress trees that Jeffers had planted cast deep shadows in this c. 1930 photograph. (Tor House Foundation Collection.)

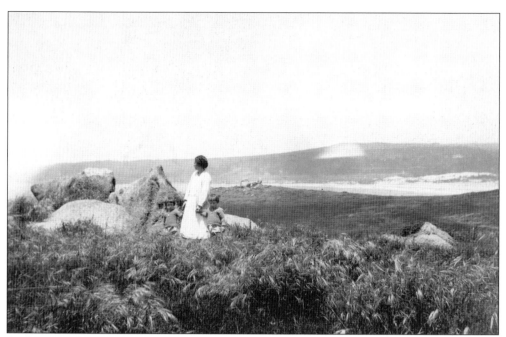

In this 1918 photograph, Una Jeffers and her twin sons Donan and Garth were standing just to the north of their home. She was looking across the barren point of land, where the grass gave way to large, granite boulders, exposing the rocky foundation of Carmel Point. It was this wildness and isolation that attracted them from the beginning. (Tor House Foundation.)

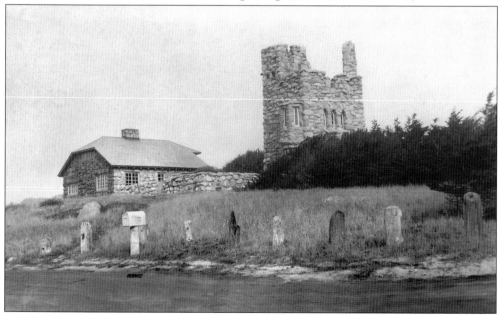

Robinson and Una Jeffers had visited Carmel in 1904, purchasing five acres on Carmel Point for $500 in 1914. Robinson apprenticed under builder M. J. Murphy to learn the art of making "stone love stone" and helped build his home with the granite rocks from his land. Later he built Hawk Tower by himself. In this c. 1930 photograph, the track that had gone around the Point is a graded dirt road. (Don Freeman collection.)

George Washington Reamer is teaching his son Bain to handle the reins of his horse in 1915. Bain, barely two years old, is watched carefully by his sister Sara Elizabeth from her pram. George was a builder who had come in 1904 to build a home for his cousin, Mrs. Wells. Later actress Jean Arthur purchased the home and treasured the lava rock fireplace that was a Reamer signature piece. (Reamer-Elber family collection.)

Bain and Sis Reamer are pictured around 1926 with their bikes in front of the neighboring Stewart home. Margaret Stewart, who owned the Hotel Stewart in San Francisco with her brother Charles, built this luxurious home-away-from-home, complete with tennis courts, a reflecting pool, and servant's quarters. In this 1948 photograph, Margaret's grandniece Ann Luker is sitting in the garden with her dog Tigger. (Left photograph courtesy Reamer-Elber family collection; right photograph courtesy Ann Luker Klein family collection.)

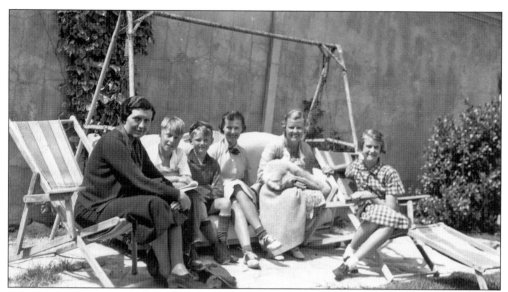

The Stewart home sat on eight lots above the little cove that is now known as Stewart's Cove. It had many beautiful details inspired by architect Julia Morgan, who designed Margaret's home in Garberville. In this 1937 photograph, the family of Margaret's brother Charles Stewart is living there. From left to right, they are Florence, Sandy, George, Jean Mary, Margaret with baby Ann, and Catherine. In the 1980s, the home was razed and the lots sold. (Ann Luker Klein collection.)

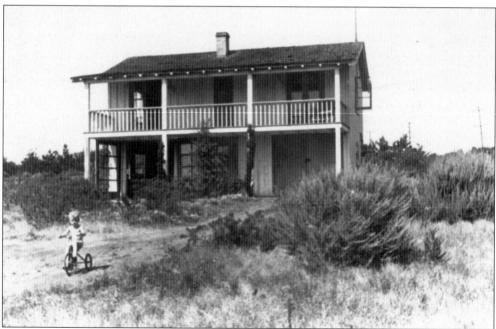

Sinclair Kerby-Miller brought his family to Carmel for several summers while he taught philosophy at the University of Missouri. He rented this little house on Rio Avenue in 1931 for $50 a month. In 1932, he photographed his two-year-old son John riding his tricycle along the sandy track to the house. John still has one of the earth-moving toys his father made for him, an ideal present, as their yard was a giant sandbox. (John Kerby-Miller collection.)

In 1925, a new Carmelite "foundation" was established. The religious order is devoted to a life of prayer. Searching for a quiet property to build their monastery, they chose a large lot on Carmel Point, and on October 23, five nuns took up residency. This late 1920s photograph shows the entrance to the convent, which was surrounded by a tall board fence for privacy. A new monastery was built in 1931 above the San Jose Creek, south of Carmel. (Pat Hathaway Collection.)

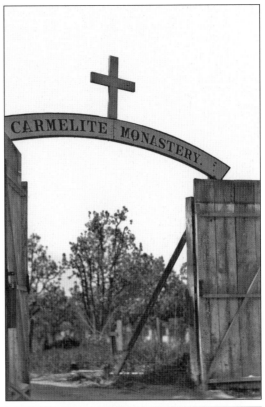

On rare occasions, the Carmelite nuns are permitted to leave their monastery, and such a moment is captured here. On August 26, 1956, 36 nuns waited to greet Pres. Dwight Eisenhower and the first lady as they visited the Carmel Mission. The Eisenhowers had come to San Francisco for the Republican convention. As a memory of their visit, Mamie Eisenhower was presented with the medal of Our Lady of Mount Carmel. (Photograph by W. A. Morgan; courtesy Monterey Public Library Collection.)

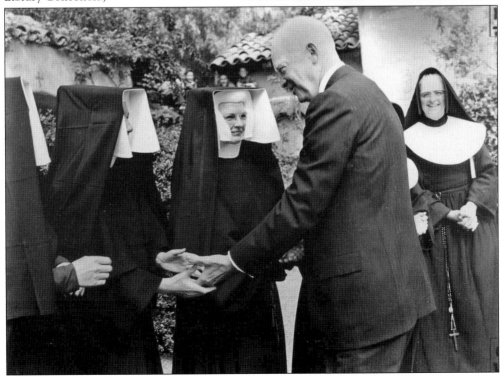

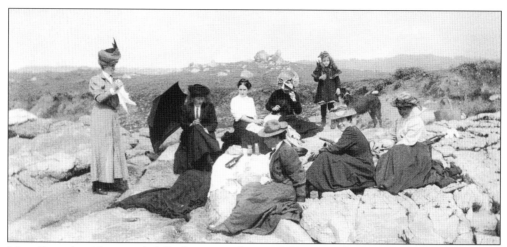

Most Carmel residents took full advantage of so much beauty at their doorstep. Picnics close to home, at Point Lobos or Carmel Point, were considered an ideal form of entertainment. These elegantly dressed women, accompanied by a little girl and her dog, are enjoying their lunch on the point, *c.* 1915. The large rocks behind them are not far from where Jeffers would build his Tor House. (Carmel Heritage Society Collection.)

Fred Farr and his wife, Janet, their children Nancy, Sam, and Francesca, and Offie the dog are waiting for friends at Stewarts Cove in 1951. A popular Carmel custom was the impromptu get-together over a meal, out-of-doors, where conversation and the exchange of ideas were the key ingredients. A lawyer and politician, Fred was eventually elected to the California senate. His son Sam became a U.S. congressman. (Francesca Farr collection.)

Six

A Paradise for the
Creative Spirit

Passionate endorsements by early residents lured their friends to Carmel. People from many creative walks of life: poets and writers, playwrights and actors, musicians, designers, dancers, photographers, sculptors, cartoonists, and painters, as well as many skilled craftspeople came to stay. It became a community of mostly tolerant, intellectual, and artistic men and women who were drawn by the beauty, inspired by the grandeur, and nurtured by the serenity of the place. Through their talents, Carmel developed into a consciously cultural community, and their vision was instrumental in preserving the natural beauty of the area and the charm of the village. Some were privileged and could devote their entire time to their art. However, the majority had to find some means to support their families, and interesting combinations of talent-trading took place. This image shows some of the fun during the street fair of the 1923 "Sir-cuss Day," one of the many fund-raisers for the Arts and Crafts Club. (Harrison Memorial Library Collection.)

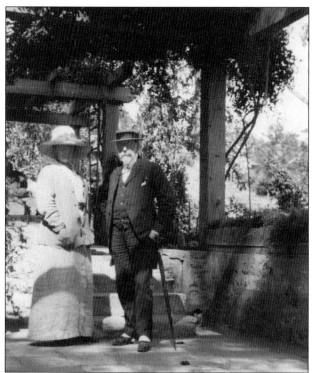

In July 1914, William Merritt Chase and Jane Gallatin Powers were photographed in front of Jane's Carmel house. Jane, an accomplished painter, studied art in Europe. Joining the San Francisco Sketch Club, she was exhibiting her work by the 1890s. She and her husband, Frank, were deeply involved in the Bay Area arts community. Frank helped found the Bohemian Club, and Jane helped found the San Francisco Spinner's Club. They wanted to bring this creative element to Carmel. (Erin Gafill collection.)

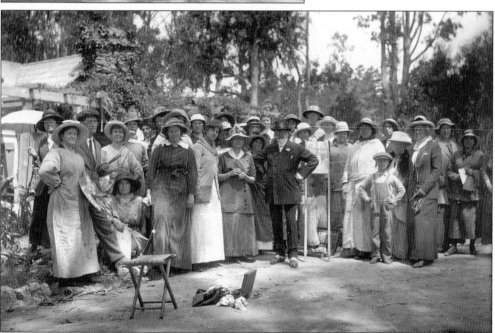

Jane Powers helped found the Arts and Crafts Club of Carmel in 1905. By 1913, the club established the summer school of art, offering botany, pottery, china painting, needlework, dramatic reading, and music, as well as drawing and painting. They recruited teachers like Mary De Neale Morgan of Carmel, Xavier Martinez from the Bay Area, and W. M. Chase from the East Coast. Chase is pictured giving a *plein air* lesson at Jane Powers's "Dunes" home in 1914. (Erin Gafill collection.)

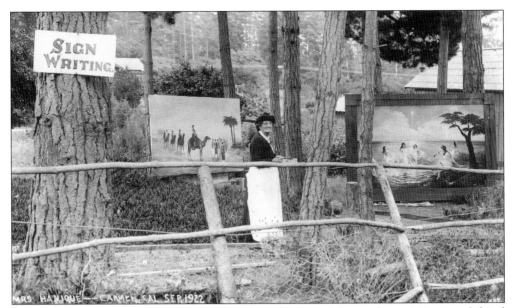

Mrs. Hanique is painting in the yard of her Carmel home, while another painting is exhibited along the fence in 1922. Other early Carmel artists included George Bellows, Arthur Hill Gilbert, Williams Keith, William Silva, Richard Partington, Jo Mora, and Ferdinand Burgdorff. To aid the exhibition and marketing of their art, the Carmel Art Association was created. Their Dolores Street gallery is owned and operated by the artists themselves. (Pat Hathaway Collection.)

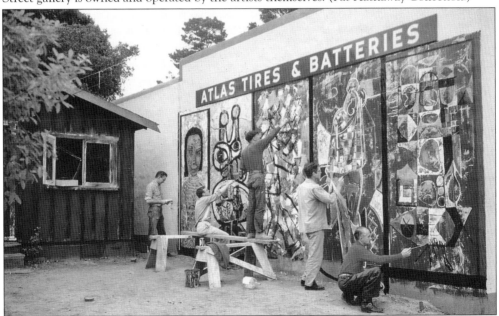

In October 1952, artists (from left to right) Larry Lushbaugh, Jay Hannah, Sam Colburn, Dick Lofton, and Ellwood Graham put finishing touches on five abstract murals on the back wall of a service station facing Sixth Avenue. The colorful—and highly controversial—15-foot pieces lasted only 18 months. Joe Kline, of Kline Electronics, "worried about the moral fiber of our American way of life" and "this monstrosity called modern art," painted them out. (Photograph by Arthur McEwen; courtesy Alan McEwen collection.)

Almost every Carmel resident became part of the creative life through local theater. Herbert Heron, a young writer and actor, saw the potential for outdoor plays, and with the help of Devendorf, founded the Forest Theater. On a foggy night on July 9, 1910, the new theater in the woods opened with a biblical drama, *David*. Pictured here are Herbert Heron as David and writer Alice MacGowan in the role of Astar. (Photograph by R. J. Waters; courtesy Harrison Memorial Library collection.)

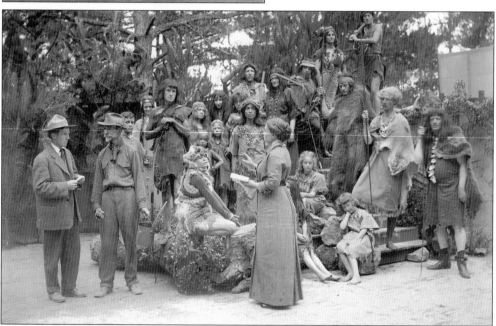

Novelist Mary Austin came to Carmel in 1902 while working on her novel *Isidro*. In July 1913, she directed her play *Fire* at the Forest Theater. Among the actors were George Sterling, Herbert Heron, Professors Rendtorff, MacDougal, Kellogg, and Harrison, and some of their wives and children. The Beast Brother was played by Opal Heron. The Forest Theater was a village affair, and whoever was not acting was providing support or was in the audience. (Harrison Memorial Library Collection.)

Carmel's schools benefited from an abundance of local talent. *The Lady of the Lake,* by Sir Walter Scott, was performed by the graduating eighth-grade class in 1915. Pictured with their diplomas in hand are, from left to right, Louie and Rebecca Narvaez, Chas DaVega, Mariam White, Gwendolyn Adams, Kenneth Ward, Ing Fratis, Adriene Anthony, and Gertrude Gates. (Harrison Memorial Library Collection.)

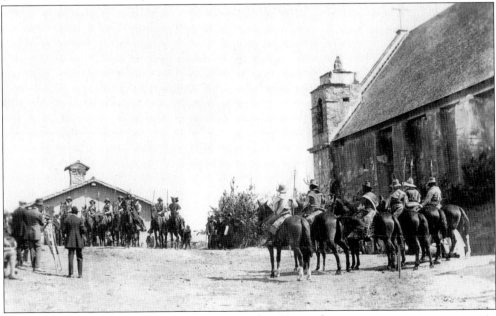

To raise funds to restore the Carmel Mission, Father Mestres began staging mission pageants in 1911. This photograph, taken October 21, 1921, shows actors on horseback depicting Spanish soldiers during the restoration cornerstone-laying ceremony. In 1915, Perry Newberry wrote the pageant *Junipero Serra,* which had a cast of 100 horses and 400 actors. The show was such a success that it was repeated at the San Francisco Exposition that same year. (Harrison Memorial Library Collection.)

Lawyer and concert cellist Edward G. Kuster learned of Carmel from his ex-wife Una and her husband, Robinson Jeffers. He moved here in 1920 and, in 1922, built the Court of the Golden Bough on Ocean Avenue, incorporating little shops like those he had seen in European cities. His buildings set a trend for business district architecture. The tall building, at the back of the complex in this 1924 photograph, is a theater he designed. (Harrison Memorial Library Collection.)

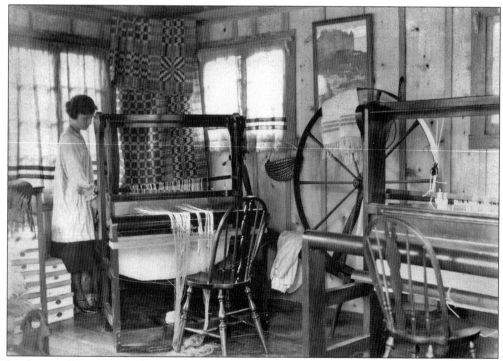

In this small cottage in the middle of the complex was Ruth Kuster's business, the Carmel Weavers. She was one of a group of talented local weavers and is pictured here, amid her looms and spinning wheels, in 1922. The cottage had been moved a block down Ocean Avenue to the Court of the Golden Bough. A little annex and window were added at the back, where theater tickets were sold. (Harrison Memorial Library Collection.)

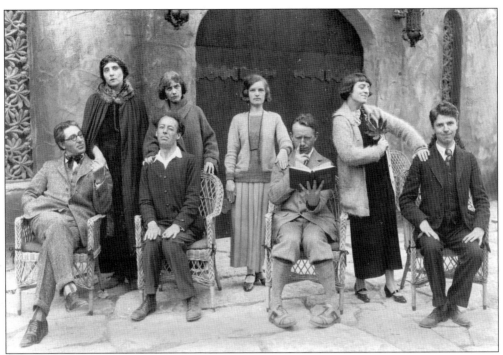

Kuster's Golden Bough Theater gained national attention in 1924 when he realized his dream of founding an acting school. He engaged Maurice Browne, "the father of the little theater movement," and his wife, Ellen Van Volkenburg, as directors. The teaching staff is pictured that summer, striking funny poses, from left to right, Carol Aronovicci, Hedwiga Reicher, Maurice Browne, Ellen Van Volkenburg, Ruth and Edward Kuster, Betty Merle Horst, and Paul Stevenson, a young theater designer. (Harrison Memorial Library Collection.)

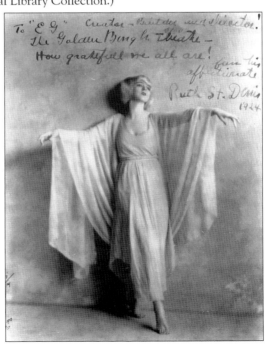

Kuster, known to his friends as "Ted," had performed with the renowned Ruth St. Denis Company. Later he helped St. Denis and her husband, Ted Shawn, form the Denishawn Dance Center in Los Angeles. This photograph of St. Denis, inscribed to Kuster, expresses her appreciation for his work and dedication to the theater arts: "To 'E.G.' creator, builder and director! The Golden Bough Theater, how grateful we all are! from his affectionate Ruth St. Denis, 1924." (Harrison Memorial Library Collection.)

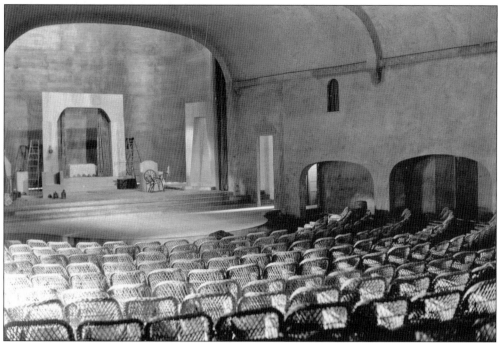

Kuster designed and oversaw the construction of every detail of the theater. In this 1924 photograph, the 38-foot-wide forestage protrudes 18 feet into the auditorium, concealing the orchestra pit. A back wall reflected the sound, and the theater lighting was state of the art. The large sky-dome gave a feeling of loftiness. Indirect lighting, warm earth tones, and cushioned, willow armchairs created an atmosphere of simplicity, quiet, and comfort. (Photograph by Lewis Josselyn; courtesy Harrison Memorial Library Collection.)

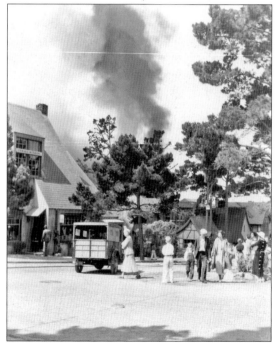

European theater expert Maurice Browne called the Golden Bough "the loveliest and best equipped theater of its size in America . . . with one exception . . . in the world." This photograph shows the plume of smoke from across the street on the morning of May 19, 1935, when it was tragically destroyed by fire. At left is Herbert Heron's Seven Arts building, where photographer Edward Weston had his studio. (Photograph by Lewis Josselyn; courtesy Harrison Memorial Library Collection.)

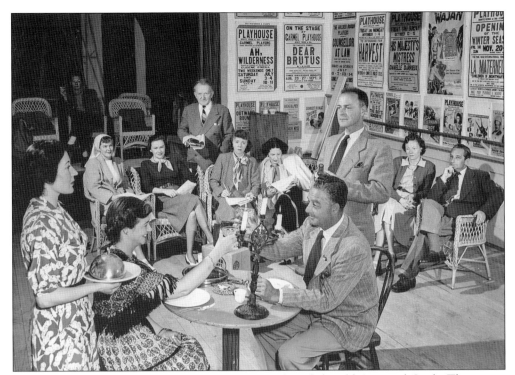

Kuster's dreams could not be torched. Having purchased the old Arts and Crafts Theater on Monte Verde Street in 1929, he later renamed it the Golden Bough Playhouse. The comedy *By Candlelight,* which had been playing in 1935 before the fire, was restaged. Here Kuster stands in back during rehearsals in May 1949. Although a great success, the play closed abruptly at the end of the week, when arson again claimed the playhouse. (Photograph by Kaldor-Bates; courtesy Harrison Memorial Library Collection.)

Galvanized into action, the community joined together to have the show go on. Here Kuster is arriving in his British Singer car, transporting props. He is aided by Ramona Weir and Officer Fred Stevens, while Jerry Ward holds the stage door open. The furnishings for the Viennese setting were on loan from almost every Carmel home, and the week after the fire, the curtain went up at Sunset Center before a sold-out house. (Photograph by Kaldor-Bates; courtesy Harrison Memorial Library Collection.)

During most of World War II, the Forest Theater, then in the possession of the city, was closed. The original founder of the theater, Herbert Heron, and Cole Weston, who had studied acting, were among the founders of the Forest Theater Guild in 1947. Cole, a man of many talents, is pictured here in 1988, splitting firewood for the traditional bonfires that are still part of the theater experience today. (Photograph by Alan McEwen; courtesy Alan McEwen collection.)

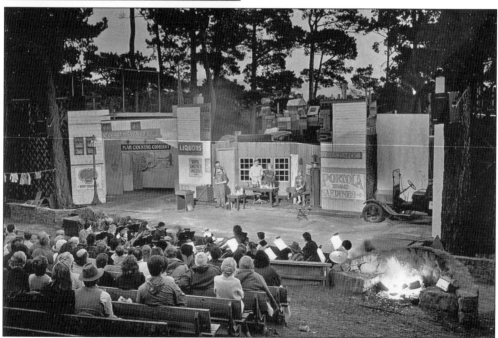

Although John Steinbeck was never a resident of Carmel, he frequently visited the homes of Carmel writers. The Rodgers and Hammerstein musical *Pipe Dream* was given at the Outdoor Forest Theater in 1986. Here, armed with blankets, jackets, and perhaps dinner or a glass of wine, the audience enjoys the play, which is based on Steinbeck's story *Cannery Row*. The pines rising beyond the set are the traditional backdrop for every play. (Photograph by Alan McEwen; courtesy Alan McEwen collection.)

Like his famous father, Edward Weston, Cole Weston was a photographer. He devoted countless volunteer hours to his first love, the theater. Directing and assisting in many plays, he is pictured here in action in 1981 in the sound booth of the Forest Theater during the play *Winterset* by Maxwell Anderson. (Photograph by Alan McEwen; courtesy Alan McEwen collection.)

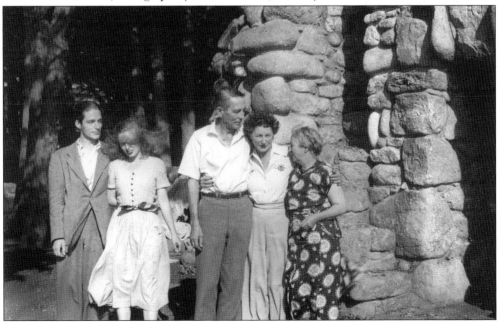

The Forest Theater, dedicated as a venue for original plays by local writers, saw its most famous performance in 1941. Poet Robinson Jeffers's first play, *The Tower beyond Tragedy*, was presented, with Dame Judith Anderson in the lead role. Anderson was a close friend of Robinson and Una Jeffers and is pictured here, *c.* 1947, between the two. On the left are Donnan Jeffers and his wife, Lee. (Tor House Collection.)

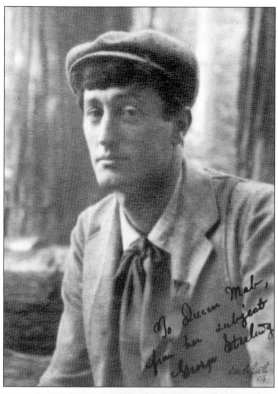

The little Lincoln Street cottage of pianist Mabel Gray Young was a favorite gathering place for the young bohemians who made Carmel their creative home, including Jimmy Hopper, Mary Austin, Vernon and Charlotte Kellogg, and George Sterling, as well as photographer Arnold Genthe, who took this portrait of Sterling in 1904. It is inscribed, "To Queen Mab, from her subject, George Sterling." (Linda Lachmund Smith collection.)

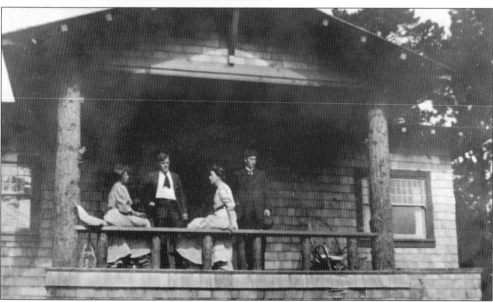

George Sterling, "King of Bohemia," was the first poet to come to Carmel, but his charismatic personality drew many from his close circle along after him. Their inspired conversations, arguments, and abalone feasts on the beach are legendary. His close friend Jack London, pictured here standing on the porch of Sterling's home along with his wife, Charmian, on the left, and Carrie and George Sterling, visited in 1906. In 1913, Sterling sold the house to Jimmy Hopper. (Harrison Memorial Library Collection.)

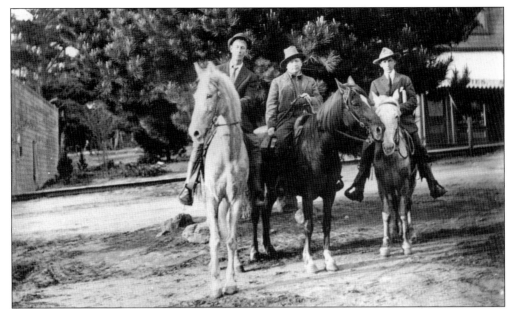

Jimmy Hopper had a law degree from and a celebrated football career at UC Berkeley and had published a volume of short stories on his experiences in the Philippines. The intellectual company and outdoor atmosphere appealed to Hopper, who worked and played hard with "the gang." To keep fit, he regularly swam out to the rocks off Carmel Beach. He is pictured here around 1915, flanked by journalists Fred Bechdolt and Michael Williams. (Harrison Memorial Library Collection.)

Lincoln Steffens's home, "Getaway," on San Antonio Street was a magnet for Carmel's intelligentsia. In 1927, Steffens, an influential editor and famous journalist, moved here with his wife, early feminist Ella Winters, and wrote an autobiography that describes his views and involvement in the leftist movement in America. In this *c.* 1930 photograph taken at Getaway are, from left to right, Lo Davidson, Lincoln Steffens, Edward Weston, Mabel Dodge Luhan, and John O'Shea. (Tor House Foundation Collection.)

By 1911, when marine painter William Ritschel came to Carmel, Devendorf had begun to carry artists' supplies to accommodate the many painters. Ritschel, who traveled worldwide in his search for subjects, always returned. He later built his home and studio in the Carmel Highlands. He is pictured here in 1920, at left, with John N. Hilliard, writer, theater director, and collector of magic tricks, at Hilliard's home in Carmel. (Pat Hathaway Collection.)

The Carmel Art Association has raised funds with annual events since its inception in 1927. One famous party was held at the Hotel Del Monte when internationally famous artist Salvador Dali visited. Dali helped create the elaborate sets. In the late 1950s, Steve and Cookie Crouch were the curators when a lively party was held at the Art Association Gallery. Pictured here, clowning around, are Eldon and Virginia Dedini, Steve Crouch, and Sophie Harp. (Eldon Dedini collection.)

The city of Carmel, with its rich artistic history, has been the recipient of some remarkable works. In 1956, artist Jean Kellogg donated her collection of original prints by world-renowned photographer Edward Weston, making it the only public collection of his prints on the Monterey Peninsula. Jean was photographed at Harrison Memorial Library's gift ceremony, along with board member Clayton Neil and Edward Weston, who is standing next to one of his photographs. (Harrison Memorial Library Collection.)

Portrait photographer Johan Hagemeyer was among the early professional photographers to have a studio in Carmel. Edward Weston soon followed, and in 1967, his friend Ansel Adams, who had moved here five years before, founded Friends of Photography along with many prominent artists and historians. About this time, Adams was photographed in Carmel with writer, historian, and preservationist Wallace Stegner. (Lloyd family collection.)

Sculptor Austin James, shown here in 1930 working on a sculpture of Rick, the son of novelist and journalist Richard Masten, was an active member of the Carmel Art Association and the Forest Theater. *Masten's Gazette* precipitated a "newspaper war " that was resolved when Masten bought the *Carmel Pine Cone* and the *Carmel Cymbal* and merged them. Little Rick would grow up to become a speaker, storyteller, poet, and minister. (Masten family collection.)

Architects Charles and Henry Greene had been operating the architectural firm of Greene and Greene in Pasadena when Charles moved his family to Carmel in 1916. Charles's mother, Leila; his wife, Ann; and daughter Alice were photographed in 1934 by Charles's brother Henry. Charles built the studio on Lincoln Street, visible in the background, from brick salvaged from the El Carmelo Hotel in Pacific Grove. (Harrison Memorial Library Collection.)

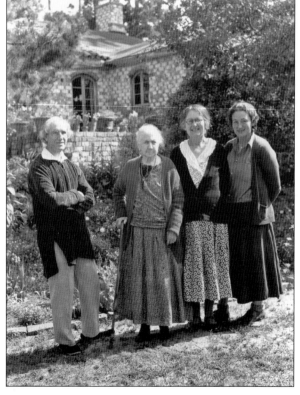

Painter and designer Hazel Watrous and pianist Dene Denny were the prime movers in forming the Carmel Music Society in 1927, which sponsored recitals and chamber-music concerts. They designed and built their Dolores Street home and studio themselves, and it became a place for informal musical performances and lectures exploring new sounds and ideas. Here Denny and Watrous are photographed with tenor Roland Hayes in 1946. (Harrison Memorial Library Collection.)

Denny and Watrous launched a concert series of modern and classical music in 1935 that has grown into the annual Bach Festival. Musicians and singers, except for soloists, were local talent in the early years. Today the three-week long, summer festival draws professionals from all over the world, but the chorus is still composed of amateurs. Some performances take place at the Carmel Mission Basilica. In this c. 1965 photograph, music is heralding from the mission tower. (Harrison Memorial Library Collection.)

Since the 1958 founding of the Monterey Jazz Festival, the area has drawn legendary jazz talent, such as Dizzy Gillespie, who played the *Star Spangled Banner* on opening night. Composer, conductor, and pianist André Previn, who was recording highly successful jazz albums at the time, came to perform for Jazz at Sunset with his wife, jazz singer Betty Bennet. Steve Crouch took this photograph during their performance. (Eldon Dedini collection.)

A great venue for jazz in Carmel was the Mission Ranch, with its piano bar and small barn, where popular dances were held. Photographer Steve Crouch took this shot in the mid-1950s of Red Norvo on xylophone, Monty Budwig on base, and Tal Farlow on guitar, performing at the barn. (Eldon Dedini collection.)

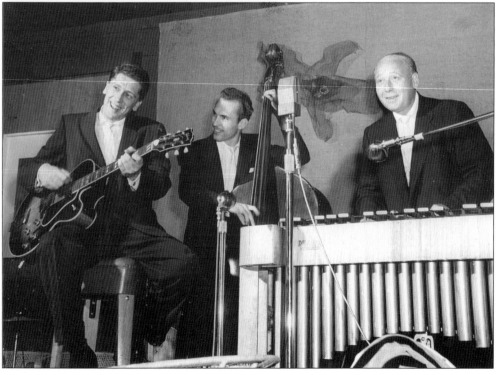

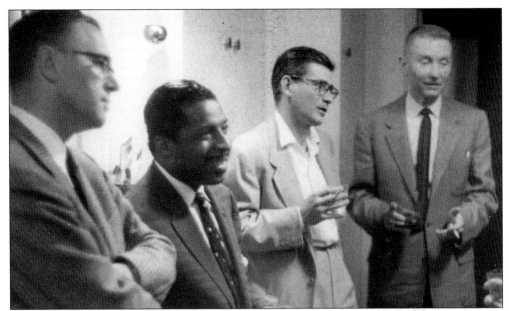

On September 19, 1955, the Concert by the Sea at Sunset Center starred Earl Garner (piano), Denvil Best (drums), and Eddie Calhoun (base) and was recorded on an all-time best-selling jazz album. After a similar concert in 1957, musicians and fans gathered to sign album covers at the home of cartoonist Eldon Dedini. Pictured here, from left to right, are Charles Simpson, Errol Garner, Jimmy Lyons (later founder of the Monterey Jazz Festival), and Harland Watkins. (Photograph by Steve Crouch; courtesy Eldon Dedini collection.)

In the early 1950s, this group of local cartoonists and illustrators gathered at Jimmy Hatlo's Carmel studio. Pictured, from left to right, are Bill O'Malley, Eldon Dedini, Don Teague, Feg Murray, Vaughn Shoemaker, and Jimmy Hatlo. Together they covered a wide range of topics, from comic strips to political cartooning, and their work appeared in *Colliers, Playboy, True Magazine,* the *New Yorker,* and the *Saturday Evening Post,* along with many other publications. (Photograph by Steve Crouch; courtesy Eldon Dedini collection.)

Daisy Bostick, who knew Carmel intimately, became a chronicler of its early traditions and idiosyncrasies when she published her recollections in *Carmel at Work and Play*, along with writer Dorothea Castelhun, in 1925. Her deep involvement and love for the village inspired this firsthand account of life in Carmel. She was photographed at her last home, the old Soto house in Carmel's Tortilla Flat area. (Photograph by Arthur McEwen; courtesy Monterey Public Library Collection.)

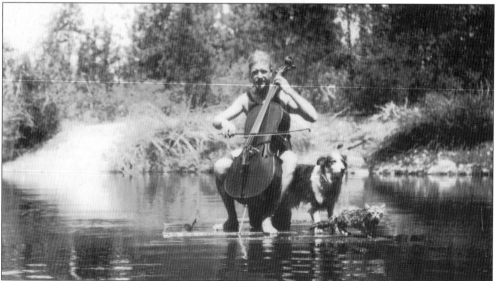

Frederick Preston Search came to Carmel as a young man in 1915. He became one of the finest cellists in America and Europe, his own compositions including the *Festival Overture* for the San Francisco Panama-Pacific Exposition. Needing more space for his hobby of raising prize-winning geese and English shepherd dogs, he moved to the Carmel Valley. He was photographed around 1930, playing his cello in the Carmel River, accompanied by one of his dogs and his cat. (Harrison Memorial Library Collection.)

Seven

A LOVE AFFAIR
WITH DOGS

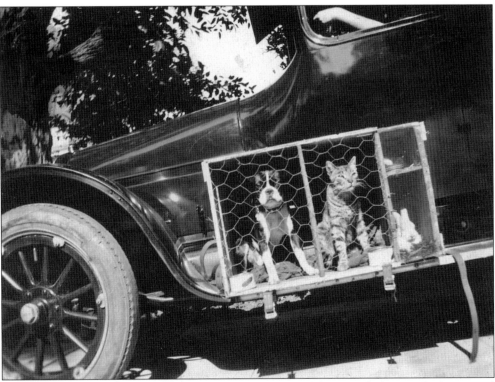

Pets have always been a part of life in Carmel, and dogs held a special place in the hearts and lives of its residents. Daisy Bostick remembered, "You can scarcely be a real Carmelite without a dog," and that the ratio of dogs to people in the business district was about five to one, in the dogs' favor. Numbers swelled in July and August when the summer people arrived with their pets. The parents of Hildreth Taylor (Masten) made special arrangements for the safe transportation of their menagerie, pictured here arriving around 1919 for the summer. According to Hildreth, it would take "three god-awful days" from Pasadena to Carmel, where they arrived safely with Wow-Wow the dog, Tootums the tabby cat, one white rabbit, and assorted white mice. (Masten family collection.)

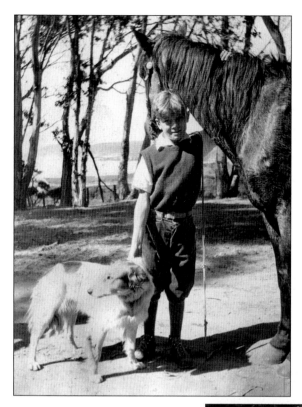

Gallatin Powers, the fourth and youngest child of Jane and Frank Powers, poses with his pony and dog near their home above the beach, c. 1918. When the inevitable time comes to say good-bye to a long-loved furry friend in Carmel, one might see a canine obituary in the paper. However, the only official grave in Carmel that does not have a cemetery belongs to the town dog, Pal, who is buried at the Forest Theater. (Erin Gafill collection.)

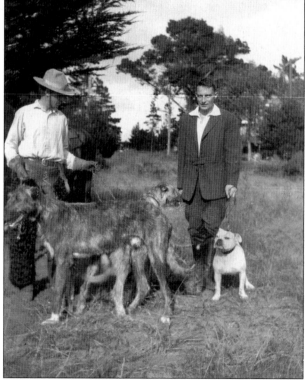

When Robinson and Una Jeffers came to Carmel in 1914, they had Una's bulldog Billie with them. The following year, this photograph was taken of Jeffers taking a walk through Carmel's pine forest with his friend, anthropologist Jaime de Angulo, who rode from his home in Big Sur accompanied by his two Irish wolfhounds. (Tor House Foundation Collection.)

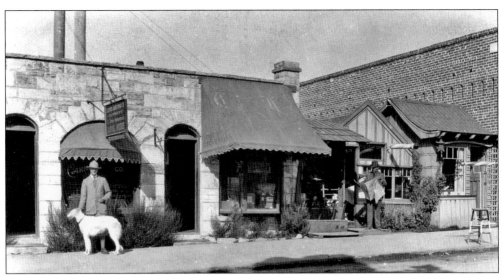

The City of Carmel passed an ordinance in 1917 mandating identification tags on dogs. Lady Vodka, the elegant, white Russian wolfhound of actor and producer Arthur Cyril, was a well-known personality around town, tagged or not. Here they are in front of the Carmel Investment Company on Ocean Avenue, around 1925. A leash law was passed in July 1927. (Photograph by Lewis Josselyn; courtesy Harrison Memorial Library Collection.)

When Robert Louis Stevenson's play *The Sire de Maletroit's Door* was presented at the Forest Theater, a dog was required. Could this beautiful Borzoi be Lady Vodka, so completely at ease on the stage? Of course, occasionally Carmel dogs or cats acquired stage experience on their own, adding to the flavor of the night by quietly wandering on stage while a play was in progress. (Harrison Memorial Library Collection.)

Attorney Eben Whittlesey and his guide dog were a familiar sight in Carmel, where Whittlesey practiced law for 30 years. Active in civic affairs, he served as mayor and attended many endless meetings. It was more than once that a long, deep German shepherd groan finally broke up a city council meeting. Pictured here is Whittlesey's first guide dog, Milt, who took his seat behind the desk for this 1941 Christmas photograph. (Debbie Sharp collection.)

Whittlesey also sang in the Bach Festival choir and helped found the Monterey Symphony, where he had his regular seat at Sunset Center. At the end of a concert, conductor Isaac Stern suggested an encore. The only voice responding was that of Whittlesey's guide dog in the balcony. Looking up, Stern asked, "Or would you rather like something else?" Here, in 1951, Debbie Whittlesey waits for her dad and his dog, who knew when he was off duty. (Debbie Sharp collection.)

Carmel was a child- and dog-friendly town to grow up in, where Gus Englund, the town marshal, returned the occasional wandering child or dog to his parents or owners. This 1936 photograph shows Charis Buckminster and her steady companion, Skippy. His doghouse had served Charis and her little friend Colin Kuster in their fantasy games. They reenacted the fire that had claimed Colin's father's Theater of the Golden Bough the year before. (Charis Buckminster collection.)

Dogs had their own column in the paper and were listed as "prominent citizens of Carmel." Readers were kept informed that "Punk Minges" delivered groceries with his master; fox terrier "Tiny Arne" hung out at Arne's barbershop on Ocean Avenue; and "Brownie Overstreet" preferred the atmosphere at the *Pine Cone* offices. Dog shows were organized with prizes for such categories as "best behaved." This 1963 photograph shows Donna Manning, whose Irish wolfhounds won prizes regularly. (Donna Manning collection.)

In 1947, the Mark Raggett family was dogless. With two active little boys, this was a sad state of affairs that, fortunately, was quickly remedied. Cartoonist Hank Ketchum's little boy, Dennis the Menace, proved to be too much for their black spaniel, Sambo, and one of them had to move. Sambo was such a perfect fit for the Raggett family that he was included in their Christmas photograph of 1948. Pictured, from left to right, are Mike, Sambo, John, Hope, and Mark. (Raggett family collection.)

Allan Knight had a lifelong passion for anything connected with the sea. He built the "Ship," a stone structure that housed his ever-growing maritime collection, next to his home on Guadalupe Street. A lover of music, family, and fun, Allan's life would not have been complete without a dog. He is pictured here with Boatswain, at his home in the 1930s. (Alene Fremier collection.)

Well-behaved dogs have long been welcomed in Carmel's outdoor restaurants and stores. The Cypress Inn offers dog treats in the bar, and the *Carmel Pine Cone* upholds the tradition of a canine column, currently called "Sandy Claws." Photographer and journalist Arthur McEwen, pictured here in 1948, joined the Carmel police force for a while. The job got him out and about and, being dog-friendly, he got quickly acquainted with that part of Carmel's population. (Alan McEwen collection.)

San Francisco Chronicle columnist Herb Caen let the Bay Area know in 1948 that in Carmel, "McEwen has just set up the State's first DBI (Dog Bureau of Investigation)." He established a file with a photograph and description of every Carmel dog, so any lost canine was quickly identified. Quipped Caen, "Don't ask me how, probably by showing the dog's picture to other dogs. He hasn't got around to foot-printing 'em yet. Thinks it might be unconstitutional." (Alan McEwen collection.)

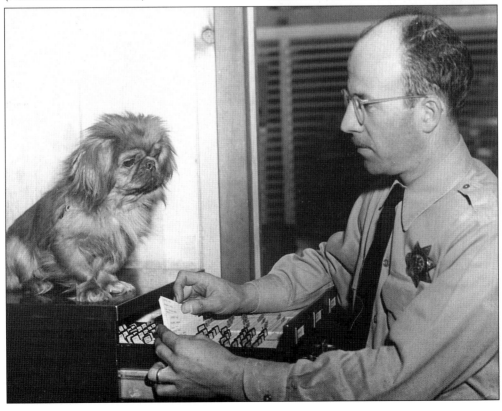

The *Carmel Cymbal* questioned the fate of a dead seal on the beach in 1926—was it removed by authorities? The next paper clears up this burning issue: "The seal has been flattened out by the ecstatic rolling of dogs and is gradually disintegrating into the sand. Shortly there will be no sign to mark the spot where once he lay." A firm hold on the dog, as demonstrated here in the 1920s, would prevent an unwelcome surprise. (Pat Sippel collection.)

It was not hard to find a cat to fill the role in *The Cat and the Cherub*, performed in August 1918, at the Forest Theater. Clara Belle Leidig, a good actress, was chosen for the lead role, but finding a Cherub might have been a bigger problem. Clara's son Glen, on his very best behavior, fit the bill, as shown in this photograph. Remembering that performance, Glen remarks laughingly that, "The cat got all the raves." (Glen Leidig collection.)

Eight

GROWING UP IN A FAIRY-TALE VILLAGE

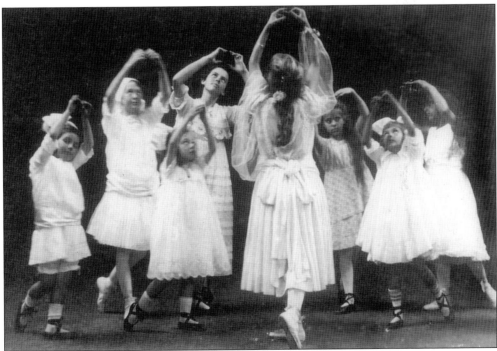

For most of us, remembering childhood takes us back to a simpler time. These photographs give a glimpse into the lives of some of Carmel's lucky youngsters who grew up playing along the woodland paths and between the empty lots, visiting child-friendly merchants for a treat. They could go fishing in a lagoon full of fish, hitch a ride on a horse, or sail a paper boat down the drainage ditch in the middle of town, all pleasures of a bygone era. Dance lessons were available from a number of teachers. In this 1920 photograph, Jeannette Hoagland, seen here from the back, teaches the Woodland Dancers, at the Forest Theater. Little Helen Newmark is third from left in this group. (Nicki McMahon collection.)

Frank Murphy, born in 1905, was the first white boy born in the village. The first twin girls were his sisters Kathleen and Rosalie, who joined the family of M. J. and Edna Murphy in 1914. The two girls are pictured here, *c.* 1916. It would not be long before they would be among the children acting in *The Inchling,* a fantasy play by Ira Remsen, in which every Carmel child had a part. (M. J. Murphy collection.)

Like many Carmel youngsters, Dorcas and Polly Powers, pictured here in 1907, had a duck for a pet. Glen Leidig remembers with humor how his own pet ducks followed him everywhere he went. He was chased away by the grocer on Ocean Avenue because his duck companions would help themselves to the lettuce sticking out of the crates displayed on the sidewalk. (Erin Gafill collection.)

This little cowgirl cannot reach the stirrups yet but seems at home in the saddle. The photograph was taken in the early 1900s in the eucalyptus grove above the beach. The grove had probably been planted in the 1850s. When John and Ann Murphy lived on that property, before they sold it to Frank Powers, they made eucalyptus paste from the seedpods and sold it as a contraceptive. (Erin Gafill collection.)

In 1929, this Mac Truck became a favorite toy of the Jeffers and Kuster boys, who lived only a block apart on Carmel Point. Here Donnan Jeffers pushes the truck along the unpaved sea road, with Shim Kuster and Garth Jeffers catching a ride. The stone house that Ted Kuster built is visible in the distance. (Tor House Foundation Collection.)

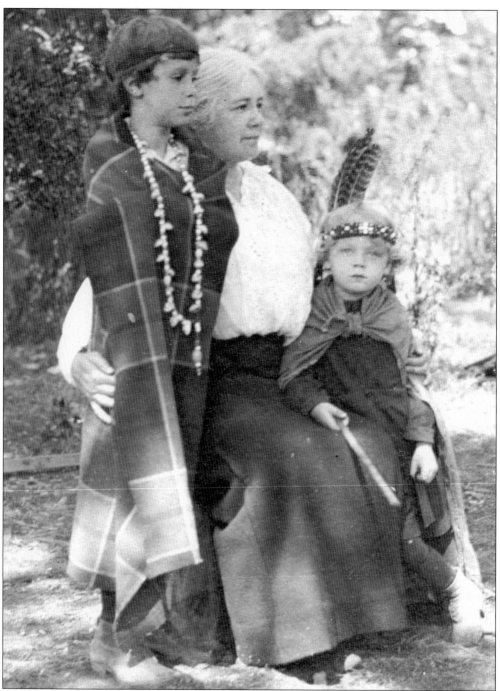

Mary Elizabeth Hart Lloyd, who had been a professor of biology at Western College for Women in Oxford, Ohio, chose to raise her sons in Carmel. The whole Lloyd family was active in the Forest Theater. In this 1914 photograph, she and her boys Frank and David perform in Mary Austin's play *The Arrow Maker*. Frank, whose father was away teaching during the school year, has fond memories of visiting Andrew Stewart at the Mission Ranch. There he would help feed the goats, play in the hay barn, or go out to the lagoon to fish. (Lloyd family collection.)

Lynn Hodges and Betty Greene each operated a stable on Junipero Street, where horses could be rented and riding lessons were given. Betty always had a lot of help and, as a reward for a good stable cleaning, the kids occasionally rode around the block. The three Levinson boys, Louis, Howard, and Homer, were photographed sitting on one of Hodges' horses, near their home on Torres Street and Mountain View Avenue, c. 1928. (Nicki McMahon collection.)

Cowboys and Indians was already a popular game in Carmel in 1906, when the Devendorf girls skirmished through the Manzanita brush in outfits made by their mother from potato sacks. Fifty years later, nothing has changed. Here, in 1955, Barney Laiolo's three boys, Chris, Toni, and Linder, camp out with a tepee in the backyard of their Mission Street home. From the fancy headdresses, it looks like they were all chiefs. (Laiolo family collection.)

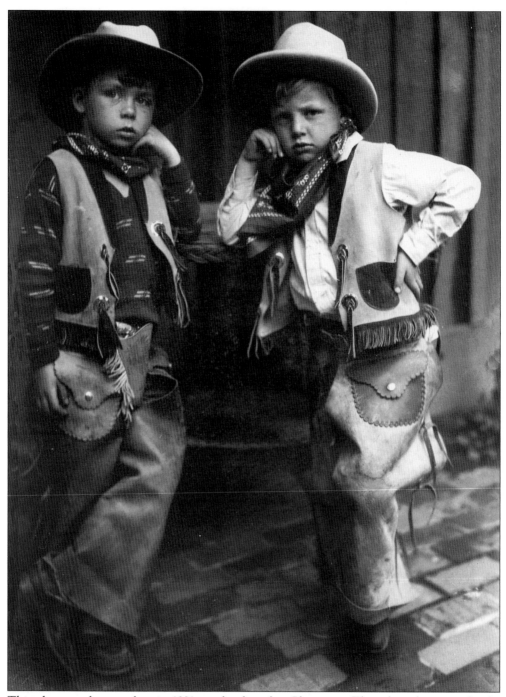

This photograph was taken in 1931 on the day after Christmas. These brand-new outfits for two little outlaws must have been delivered to the home of Thorne and John Boke by Santa himself. Their dad, Berkeley professor George Boke, might have taken them to Louis Slevin's store on Ocean Avenue, a favorite treat for Carmel kids at the time. The store was full of curios, ship models, cameras, coins, and stamps from all over the world. (Photograph by Lewis Josselyn; courtesy Lloyd family collection.)

Fast friends Lillian Devendorf and Mabel Mattern stand in the middle of Lincoln Street in 1903. While playing in the street is not advisable today, a rural atmosphere, without sidewalks or streetlights is still part of Carmel's charm. The cottage at right is typical of the 12 portable houses that Lillian's father purchased that year in San Francisco. When he reordered later, he was surprised when he got a barn and a whole shipment of doors instead. (Jane Galante collection.)

Every year, a group of more than 100 boys from the San Francisco Columbia Park Boys Association got a chance to spend the month of July camping in Carmel. In appreciation, the popular group helped out with the summer fund-raising events of the Carmel Arts and Crafts Club. In this 1904 photograph, two of the boys and baby Mariam White are having fun with Dr. Peake's donkey Betsy, while Prince, the White's Great Dane, looks on. (Harrison Memorial Library Collection.)

One of the many decorated floats in the Fourth of July celebration of 1904 featured Ivy Murphy, standing tall on the back of a cart, in the role of Goddess of Liberty. Marion Devendorf, sitting at left, is one of the little girls attending her. (Jane Galante collection.)

Everybody was part of the Fourth of July parade in 1904. Even Prince the dog, who belonged to the Reverend Willis White's family, is pressed into service. Harnessed to a wagon decorated with American flags, he is giving his little mistress, Mariam White, a ride along the wooden sidewalk on Ocean Avenue. Marion Devendorf, in a dress of patriotic fabric, guides the carriage. (Harrison Memorial Library Collection.)

Nine

FUN AND GAMES
AT THE BEACH

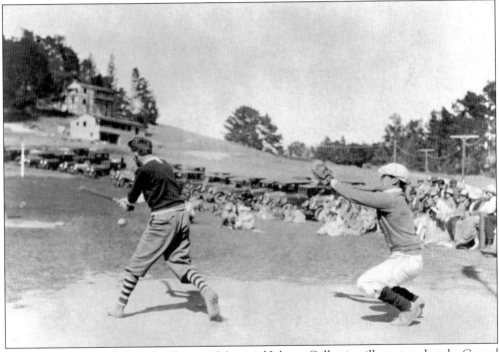

This 1920s photograph from the Harrison Memorial Library Collection illustrates what the *Carmel Cymbal* describes in 1926, the game that became a Carmel obsession:

> There is, in this seaside town of Carmel, a baseball league the like of which does not exist in all the rest of America. Six teams make it up, the indoor bat and ball are used, the players are a cross-section of present-day society—bankers, carpenters, artists, delivery boys, truck drivers, school teachers, housewives (for the women and girls play along with the men) running in ages from twelve to seventy years, and with this so-called baseball played on a diminutive side-hill diamond among the pine trees overlooking the sea, with broomstick-like bat and grape-fruit-like ball, there is a seriousness and at times a cave-man savagery that causes the hair of those in control of the league to curl violently from the roots outward. One would think that the fate of the nation depended on the way in which the Abalone League games are run, and that the business of life consisted not in running grocery stores or selling real estate, but in winning one's game on Sunday afternoon.

Aviator Thorne Taylor, recipient of the Croix de Guerre, out of sheer desperation for some kind of amusement not involving the stage, coaxed a few residents down to Carmel Point to try the playground version of baseball in 1921. Catching on like wildfire, the competition became so fierce that, in 1926, the opinion of baseball commissioner Judge Kenesaw M. Landis was sought to settle a dispute. Here Virginia Stanton and Wilma Hervey defend the honor of their team, c. 1923. (Harrison Memorial Library Collection.)

Sis and Bain Reamer, seven and eight years old, were put in right field, where the grass had to be mowed first so they could be seen. Many a ball joined the abalone down among the rocks above the beach, giving the league its name. After windows were broken on Carmel Point, the game moved to Carmel Woods, where up to 100 cars could park. These too boys are ready to take part if called upon in 1928. (Pat Sippel collection.)

Scotsman Philip Wilson came to Carmel in 1905 and later built the only golf course. Its nine holes were laid out on Point Loeb (now Carmel Point), following the shoreline from the south end of the beach to the mouth of the Carmel River. Although abandoned during World War I, the clubhouse on San Antonio Avenue and Fourteenth Avenue is a residence today. Included in this c. 1914 photograph are Wilson's daughter Grace and son James. (Harrison Memorial Library Collection.)

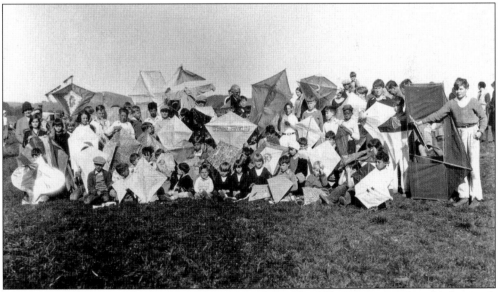

Rev. Willis White started the Carmel Kite Festival in 1931. Old-timers remember the fire truck loading up children for a ride to the beach at the start of the festival. Kites had to be homemade, and prizes included most unique, most colorful, highest flying, or fastest to reach 100 feet. For many years, school shop teacher Ernest Calley, pictured in the center among the kids in the 1940s, carried on the tradition of the festival. (Harrison Memorial Library Collection.)

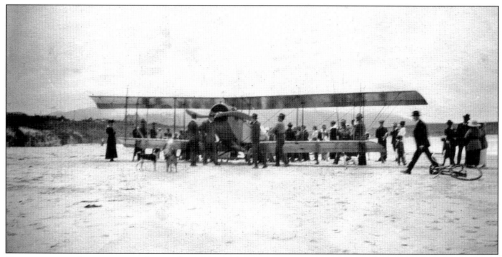

Barnstorming became popular in the 1920s, when many young men who had learned to fly during World War I were not about to give up the exciting activity. After the war, the military sold off many of its biplanes cheaply, and barnstorming became the new hot phenomenon. Exactly who or when this biplane landed on Carmel beach nobody seems to know, but there were several pilots among Carmel's residents. (M. J. Murphy collection.)

One such home-grown barnstormer was Billy Staniford, the son of "Doc" Staniford, who operated Staniford's Drug Store. On a calm day, at low tide, the wet sand on the beach made a ready airstrip. In this c. 1924 photograph, Ursula Hooper poses next to a pilot and his plane. When the Mission Ranch was developed in 1926, an airstrip was mowed. The $1 plane rides offered from there served to attract attention to the club. (Linda Lachmund Smith collection.)

Aviator Charles A. Lindbergh got his start as a barnstormer. Already famous for his 1927 solo trans-Atlantic flight, he came to the Monterey Peninsula to test his glider on a flight over the Pacific Coast. In this 1930 photograph, the glider is being prepared for launch from the Palo Corona Ranch above Carmel River's mouth. Lindbergh flew the glider about two miles out over Carmel Bay, then turned southward and landed it about seven miles down the coast. (Photograph by W. L. Morgan; courtesy Monterey Public Library Collection.)

The general staging area for the glider trials was in the large, open field on the south side of the Carmel River lagoon. Charles Lindbergh was photographed there, in the midst of a Boy Scout troop, in March 1930. Carmel has had an active scout organization ever since the 1910 visit by Sir Baden-Powell, founder of the Boy Scout movement. In 1925, the troop was officially given the number 86. (Pacific Grove Museum of Natural History Collection.)

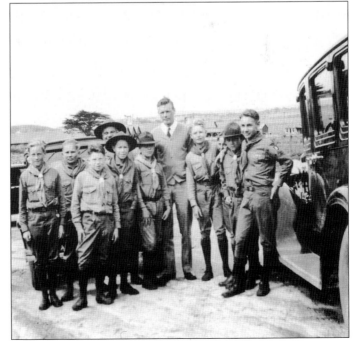

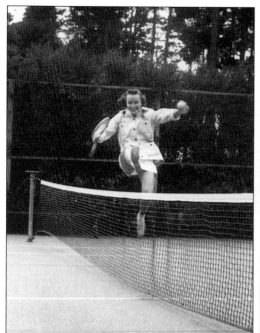 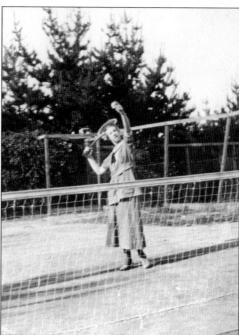

Carmel had a horseshoe pit near the business center, and many a shopkeeper took time off for a game, leaving instructions to customers to "help themselves and leave the change on the counter." Tennis, another favorite pastime, was played on courts in Carmel Woods. The 1930s photograph on the left shows Jean Draper vaulting over the net. Fashion had changed and the trees have grown since c. 1915, when the young woman at right was photographed on the court. (Left photograph courtesy Susan Draper collection; right photograph courtesy Erin Gafill collection.)

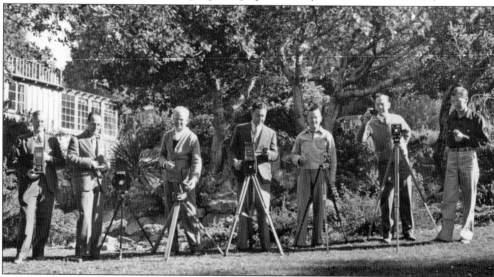

A number of excellent photographers were based in Carmel, and they experimented with new equipment, film, and color. Louis Slevin's store, and later Dale Hale's Carmel Camera Shop were well stocked with anything needed for this exciting hobby. It was not long before the Photographers Club was formed. Pictured here, in 1940, are some members of the club. (Pat Hathaway Collection.)

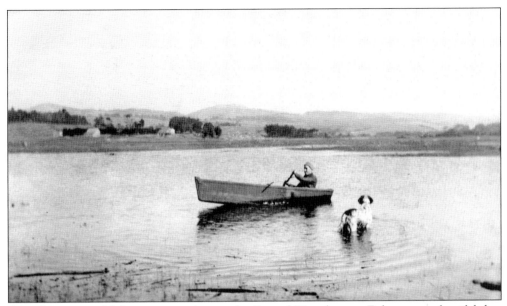

Great hunting and fishing were as close as the Carmel River lagoon. Fish were so plentiful that little Isabel Martin, crossing the lagoon on her way back from Bay School, would scoop up fish in her skirts and bring them home for dinner. Frank Lloyd, quoting Andrew Stewart, tells of townspeople with pitch forks, baseball bats, and bare hands coming to collect fish. In this 1917 photograph, Harry Lachmund fishes while his dog Ol' Possum watches carefully. (Linda Lachmund Smith collection.)

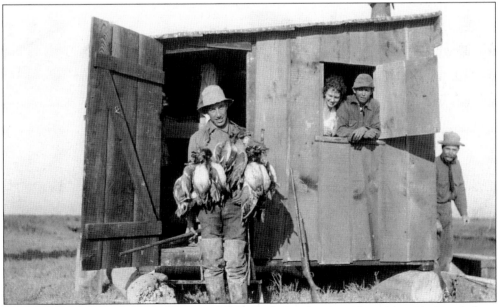

Mabel Gray Young's two sons Harry and Otto Lachmund enjoyed hunting with friends from this duck blind, which was set up in the wetlands near the river's mouth. Visible on the right, the tip of the boat is chained to the shed so rising waters will not float it out to sea. This 1910 image catches Harry in the doorway at the blind, with enough birds for several dinners. (Linda Lachmund Smith collection.)

The youth population increased sharply after World War II. In 1949, the Carmel Youth Center was founded as an activities center, available for youngsters to meet after school. A big supporter, Bing Crosby brought the Crosby Golf Tournament to the Monterey Peninsula. Many locals remember the colorful "Bing Mobiles" from which kids sold refreshments. Fund-raising also included talent shows. Tony Schaurer, Mike Taylor, and Mike Draper, assisted by Veronica Taylor, prepare to star in the 1960 *Christmas Capers*. (Carmel Youth Center Collection.)

Through Bing's Hollywood connection, fabulous professional costumes were available for another popular fund-raiser: *The Follies*. The talent shows, presented on the stage at Sunset Center, were a treat anticipated every year. In 1953, Lucy Carmalt, Pat Ricketts, Gail Fisher, Pam Koehler, Toni Hamilton, Connie Nielsen, Sally Spur, Leigh Buchanan, Linda Malis, and Penny Schuefloten appear, all decked out in Charleston outfits, in the *Youth Follies*. (Carmel Youth Center Collection.)

The desire to stay healthy, be active, and enjoy all the fun is nothing new. Film actress Kim Novak, who lived in the Carmel Highlands for many years, contributed to the health craze by giving popular fitness classes. On many a beautiful day, she could be seen holding her classes on one of Carmel's beaches. In October 1981, Alan McEwen photographed her leading an exercise class at the Carmel Boy Scout House, which some jokingly called Kim's Gym. (Alan McEwen collection.)

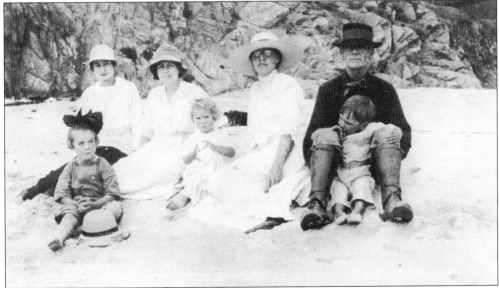

Carmel is fortunate to have two magnificent beaches. It is only natural that they were, and still are, favorite places to play and have fun. In the early days, the cove below the tip of Carmel Point was called Reamer's Cove. George Reamer and his wife, Cathrine, seen here c. 1916 with their two children Bain and Sarah Elizabeth ("Sis"), are joined by some friends at the cove. (Reamer-Elber family collection.)

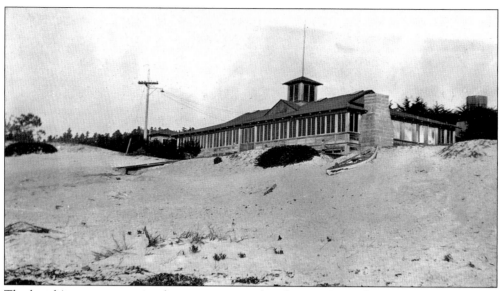

The beach's entertainment value was recognized early; in 1888, Delos Goldsmith began the construction of the Bath House (seen here in 1922). Standing at the end of Ocean Avenue, above the beach, its grand opening took place in 1889. It quickly became the social center for parties, dances, and club meetings. The city worried about liability and the cost of upkeep, and sold the Bath House in 1929. The new owner, Mrs. W. C. Mann, had it torn down the same year. (Harrison Memorial Library Collection.)

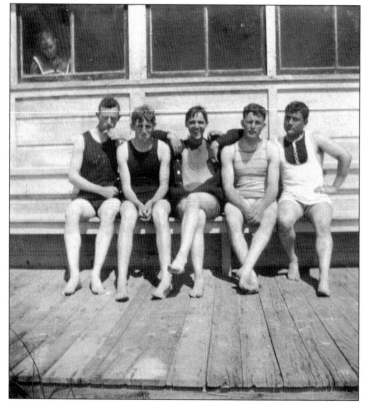

These five young men sit outside the Bath House in 1908. Their bathing suits were quite avant garde. Only six years earlier, writer Mary Austin remembers "the tremendous protest on the part of the Methodists of Pacific Grove against the Stanford students who were going in to bathe with bathing suits which came above their elbows and not quite down to their knees." (Erin Gafill collection.)

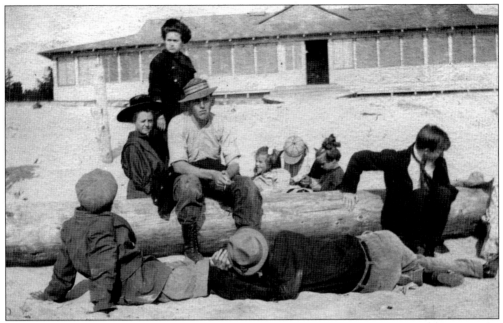

At the Bath House, beachgoers could get peanuts, candy, popcorn, sandwiches, and lemonade. This 1908 photograph by Madeline Powers shows her friends lounging around a driftwood log on the beach. Pictured are Daphne and Knight Jordan (with hats) on the log, and Mervin Larson, wearing a neck tie. The two little girls are probably Madeline's sisters Dorcas and Polly. (Erin Gafill collection.)

On the left, in 1910, Frank Devendorf's wife, Lillie, and their daughter Lillian walk along the boardwalk, which stretched from the main door of the Bath House to the beach. For anyone interested in swimming, dressing rooms were available and towels could be rented. The Powers family lived so close to the beach that a young visitor is in her swimming attire on the patio of their home in the c. 1908 image at right. (Left photograph courtesy Jane Galante collection; right photograph courtesy Erin Gafill collection.)

These children were photographed on Carmel Beach in 1908. When Frank Devendorf's girls were in town, they often lured their father down to wade in the surf; he loved the beauty and serenity of the beach. In 1922, after his partner Frank Powers had died, he was approached to have a major resort hotel built in the dunes. Devendorf sold the property to the city for a fraction of its value, to be preserved and enjoyed by all. (Erin Gafill collection.)

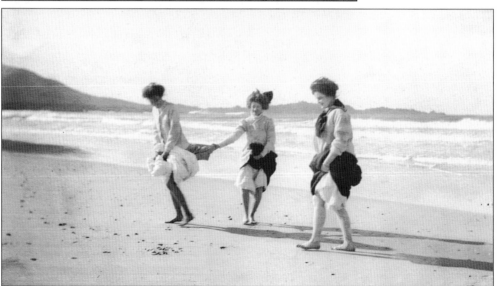

These three young women, playing near the surf with their skirts and petticoats hitched up, could have been photographed yesterday: only their fashion belies the 1908 date of this photograph. In a way, they epitomize the stories of women who happen upon Carmel and decide to stay. In 1930, Anna Heaton was traveling from Chicago—where she had been a cook for Oscar Mayer —when she called her husband, asked him to sell everything, and told him to come because she would never leave Carmel. (Erin Gafill collection.)

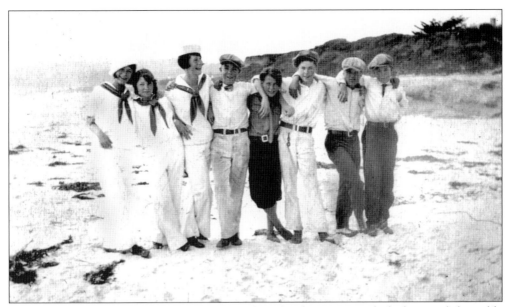

Some lucky people were actually raised here. These local youngsters, decked out in fashionable sailor suits, enjoy a school picnic on Carmel Beach around 1926. Note the Monterey Cypress tree growing above the bluff. These native Cypress trees were planted all along above the beach by Devendorf's crew to enhance the beauty of the beach. Many of the 100-year-old trees remain today. (Pat Sippel collection.)

Near this spot, legendary bohemian abalone feasts were held 50 years before photographer John Livingstone captured this 1955 image of Lacy Williams. Perched on the rocks at Carmel Point, she reads for her favorite subject, English literature. Lacy's parents, Mona and Henry Meade Williams, and grandfather Jesse Lynch Williams were all award-winning writers. Influenced by her father and his bookshop, she was motivated to seek out this place that has inspired creative souls for decades. (Lacy Williams Buck collection.)

Author Sinclair Lewis lived in Carmel long before he became the first American writer to win the Nobel Prize for Literature. Returning in 1933, he was surprised that "somehow, strangely enough, Carmel has survived and retained much of the atmosphere that made it famous." He warned, "For God's sake, don't let the Babbits ruin the town. You've got every other city in the country beat." After journalist Ernie Pyle's visit in 1936, he remarked having "seen only two or three mansions, and they were grotesque amid the soft quietness of the town." Since then, many "mansions" have replaced aging cottages, and conserving what remains is of true concern. The solution to the grand ambitions of some may rest in the ritual Sand Castle Contest. Every fall, dreams of great castles are realized, the mansions are admired and judged, and their creators hope to win first prize. The sculptures are fleeting, however, as the next tide will restore Carmel Beach to its pristine former self. (Photograph by G. A. Short; courtesy Harold A. Short collection.)